ON STONE

*The Art and Use of
Typography
on the Personal Computer*

*Sumner Stone
Design by Brian Wu*

*Bedford Arts, Publishers
San Francisco*

First Edition
Printed in Japan

Project Editor: Stephen Vincent
Text Editor: Carol Henderson
Production: Brian Wu

Library of Congress Cataloging-in-Publication Data

Stone, Sumner, 1946–
 On Stone : the art and use of typography on the
personal computer / Sumner Stone : design by Brian Wu.
 p. cm.
 ISBN 0-938491-41-5 — ISBN 0-938491-28-8 (pbk.)
 1. Printing, Practical – Layout – Data processing. 2.
Type and typefounding – Data processing. 3. Electronic
publishing – Style manuals. 4. Desktop publishing –
Style manuals. I. Title.
Z246.S75 1990 90-14447
686.2′2544–dc20

Published by Bedford Arts, Publishers
301 Brannan Street, Suite 410
San Francisco, CA 94107-1811

Contents

Foreword

Working with the basic tools of typographic technology, namely, with the crafting of movable metal types within the rich legacy of typefounding that stretches unaltered over five hundred years, has been the major substance of my life.

This technology presupposes a tighter and slower process in the shaping of typography compared to today's computer technology. The type module in metal has always related to the human scale, where a three-dimensional typeface of various sizes can be seen and touched by the hand, a tangible referent.

In 1987 Sumner Stone brought to my press a Macintosh and LaserWriter and suggested that this typographic tool might be of interest and open new paths for typography.

At first, I wondered how I could ever master this complex computer language, so puzzling and beyond the reach of my old typographic metal hands. Yet, with the help of Sumner and Brian Wu, I slowly came to know and respect this inviting tool. At this time I had the privilege to watch Sumner bring to life his Stone type family and participate in testing the many different weights and sizes. What impressed me was the ease of shaping the text on the page. In rapid sequence, sizes, leading, and widths could be changed at will. But what did this new freedom for the typographer mean in the larger context? It meant that without a clear typographic knowledge and experience in the craft, freedom could lead to chaos.

When working with the Macintosh, I'm constantly reminded of my training in the use of metal type that flows so well into this technology. This book is a beautiful example of that flow and continuity.

Jack W. Stauffacher
The Greenwood Press
San Francisco October 1990

Preface and Acknowledgments

This book has gone through a fairly long evolution. It began in 1987 as a summer project at Adobe Systems Inc. for two graduate students from the Yale University graphic design program, Brian Wu and Min Wang. Their assignment was to use the unreleased Stone typefaces, later to become the ITC Stone typefaces, to produce all the kinds of typographic material they could think of – as Jack Stauffacher said, "to put the type through its paces." The result was the draft of a book, whose structure we adapted for the booklets that Adobe publishes to introduce the Adobe Originals typefaces. These booklets contain three main sections – a description of the rationale for the new typeface, examples of the typeface in use, and a section containing traditional specimens of the type.

On Stone has gone through a number of transformations since that time, including a new text, many new illustrations, a new organization, and a new format and design by Brian Wu. There are many people to thank: Brian for his intuitive understanding of the project from the beginning, his general resourcefulness, his fine sense of the complex design issues, and his excellent work in composing the book. Min Wang for his vision, during that exciting summer, of how the type might be used. Jack Stauffacher for his firm support, wise counsel, and many other contributions to the book, both direct and indirect. John Warnock,

Chuck Geschke, and Adobe Systems for creating an atmosphere of innovation in which new typefaces as well as new software could be developed, and for supporting the Stone typefaces from the beginning. Stephen Vincent for seeing the value of the book and persisting through the various trials of producing it. Carol Henderson for helping me develop the manuscript. Lance Hidy, Robert Slimbach, and Carol Twombly for reading the manuscript and offering comments, and Carolyn Coman for reading and listening for my voice. Alvin Eisenman for sending me Brian and Min. Chuck Bigelow for many conversations and thoughts over the years about type design and typography. Frances Butler for the conversations about typographic voices. The late Stephen Harvard for his encouragement. Clifford Burke for writing a thoughtful early treatise about the types. Allan Haley, Aaron Burns, and the International Typeface Corporation for their enthusiasm about the Stone typeface family from the very early days. Bob Ishi for his calm presence and persistence, his stalwart help, and his superhuman production of the thousands of bitmaps that were necessary for creating the screen fonts.

Thoughts on Stone

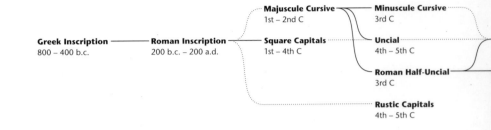

Greek Inscription 800 – 400 b.c.	Roman Inscription 200 b.c. – 200 a.d.	Majuscule Cursive 1st – 2nd C	Minuscule Cursive 3rd C
		Square Capitals 1st – 4th C	Uncial 4th – 5th C
			Roman Half-Uncial 3rd C
			Rustic Capitals 4th – 5th C

Thoughts on Stone

Typography – the art of writing with the aid of machines – has long been a specialized field, inaccessible and even mysterious to all but a few practitioners. While readers might have vaguely appreciated the ease with which they could read a well-composed page, they had no notion of the inner workings of designing, choosing, and arranging type. Computer technology has brought about a fundamental change in this impersonal relationship. Through the seeming magic of the cathode-ray tube, the laser beam, the computer chip, and the software that makes everything work, anyone with access to a personal computer can compose documents that were once the province of the professional typesetter. We are no longer the passive recipients of typography, many of us make it.

To design and typeset a printed piece is a complex task: we must choose typefaces, sizes, letterspacing, line lengths, line spacing, indents, margins, and many other things. In doing this work, we are joining the tradition of typographers. Whether a novice or a master, we are connected by a common experience with the hundreds of generations of people who have made formal written records.

New typographers find that computer technology offers an overwhelming number of design choices, which few people have more than an intuitive basis for making. Our general educational curriculum does not include the formal training in typography that would help us judge which typefaces to select and how to use them. We learn a meager amount about letters and their composition when we learn to write and type in school. Strangely enough, even graphic designers frequently get only cursory training in the composition of text during their professional education.

The computer also offers the possibility of discovering a new, more personal relationship with letterforms. Working directly with typefaces, we begin to see letters in a new light, as if we were seeing plants or animals that were previously invisible to us. Like the colonies of pink, orange, and purple creatures we discover in a tide pool, letterforms and typefaces are living systems. Their stems, branching, arms and ears, serifs, bowls, arches, and tails are the physiology of a veritable kingdom of typographic flora and fauna.

This more intimate awareness of letterforms can also lead us to appreciate the organic nature of written communications. Whatever the product of our finished work – a book, newspaper, magazine, brochure, invitation, memo, poster – it is more than an isolated, machine-made communication – a technological construct in a vacuum. Each document grows out of a human design process. This process varies over an enormous range, from hasty, uncaring mechanical assembly through the attention to detail of the professional typographer to the loving care of the master.

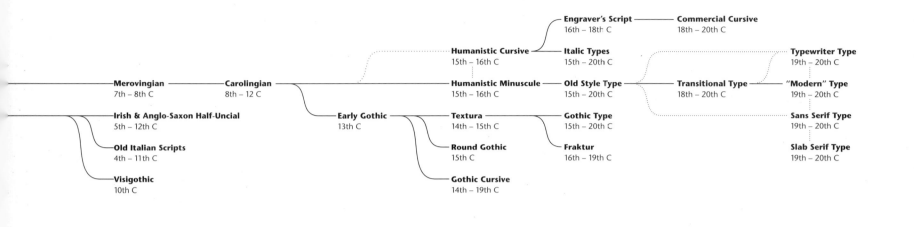

| | | | Engraver's Script ─── Commercial Cursive |
| | | | 16th – 18th C 18th – 20th C |

Humanistic Cursive
15th – 16th C

Italic Types
15th – 20th C

Typewriter Type
19th – 20th C

Merovingian ─── Carolingian
7th – 8th C 8th – 12 C

Humanistic Minuscule
15th – 16th C

Old Style Type
15th – 20th C

Transitional Type
18th – 20th C

"Modern" Type
19th – 20th C

Irish & Anglo-Saxon Half-Uncial ─── Early Gothic
5th – 12th C 13th C

Textura
14th – 15th C

Gothic Type
15th – 20th C

Sans Serif Type
19th – 20th C

Old Italian Scripts
4th – 11th C

Round Gothic
15th C

Fraktur
16th – 19th C

Slab Serif Type
19th – 20th C

Visigothic
10th C

Gothic Cursive
14th – 19th C

Because typography and type design have, until recently, been the province of professionals, useful literature on the subject has been hard to find. The intention of this volume is to provide the reader with pathways into the vast territory of typography and type design. I am addressing in particular the growing ranks of typographers – those who use type to compose written communications; type designers – those who draw the collections of letterforms we call typefaces; and graphic designers, who must also be typographers as part of their profession. The book consists of three parts. "Thoughts on Stone" is a brief look at the history of type design and the process of designing the Stone typefaces with the aid of the computer. "Working with Stone" is a case history in typographic design, using the Stone typefaces to design examples of many different kinds of typographic communications. "Looking at Stone" consists of a comprehensive set of specimens of the Stone typefaces – a tool for the typographer who is using Stone.

The Begats

Child: Where do typefaces come from?
Parent: The stork brings them.

Of course, the stork does not bring them, and wherever they come from, there doesn't seem to be much sex involved in their conception (though there may be exceptions to this). It is true, however, that new typefaces generally seem related to old typefaces in a way that is at least faintly reminiscent of the relationship between child and parent. Perhaps that is why the language of biological evolution has frequently been used in describing the history of type.

Family trees of letterform "evolution" are common in texts about the history of writing. The subtitle of Daniel Berkeley Updike's important work *Printing Types, Their History, Forms and Use*, published first in 1922, is *A Study in Survivals*, echoing Darwin's phrase "the survival of the fittest."

Although typefaces have been evolving for a very short time compared to plants and animals, the number of species of typefaces is still impressive. Most readers overlook the fundamental complexity of even simple text passages, which include not one alphabet style but at least four (roman upper- and lowercase, and italic upper- and lowercase), while typographers find not four styles, but thousands. These many typeface styles are grouped, like creatures, into various classes and categories, the most basic of which is the type family. As a rule, type families contain the roman and italic versions of different weights of the typeface; they sometimes also contain different condensations of the typeface, and in a few cases, as with the Stone family, different subfamilies.

The astounding variety of letterforms created since Roman times continues to grow, abetted most recently by computer technology. We would like to think, though, that the process does not exactly follow the biological model of random genetic variation – that there is a creative impetus that springs from our mind and soul.

SPQR

SENATVS·POPVLVSQVE·ROMANVS
IMP·CAESARI·DIVI·NERVAE·F·NERVAE
TRAIANO·AVG·GERM·DACICOPONTIF
MAXIMO·TRIB·POT·XVII·IMP·VI·COS·VI·P·P
ADDECLARANDVM·QVANTAE·ALTITVDINIS
MONS·ET·LOCVS·TAN IBVS·SIT·EGESTVS

However new letterforms are invented, their survival generally depends on acceptance by an audience that has invested a great deal in learning to read and write using the current alphabet styles. Designs that stray too far from the current forms generally cause discomfort to the reader and fade from use. Radical mutations in the history of writing tend to die quickly without producing any offspring. Letterform evolution, like biological evolution, is inherently conservative and usually proceeds slowly. The lowercase letterforms that we use today, for example, have changed little from those that were written by ninth-century European scribes. Even more remarkable is the startling clarity with which Roman inscription letters, such as those carved on the Trajan Column in A.D. 112–113, strike our modern eye.

What brings about change, then? Certainly technology influences letterforms in a variety of ways. Sometimes it has a direct impact, as with the invention of the typewriter in the nineteenth century. At other times the technological imprint is harder to discern. Even a major innovation like the invention of movable type in Europe had little immediate effect on letterforms. Instead, the first printed books were creditable copies of the contemporary manuscripts of mid-fifteenth-century Germany.

Use is another factor that can lead to changes in typographic forms. As letterforms are placed in different environments, they become adapted to their new surroundings. The mixing of typefaces from different families is a good example of this phenomenon. The Western idea of using different styles for different functions started at least five hundred years before the invention of printing. Formal styles that had once served for writing the main body of text – Roman capitals, square capitals, rustic capitals, and uncials – found new environmental niches in the more complex typography (actually calligraphy) that began during Charlemagne's reign. In the Carolingian period these styles came to be used for special purposes such as headings or initials.

When different styles have been mixed successfully for some time, type designers begin to make integrative modifications in one or both styles in order to make them more visually compatible. The use of Roman capitals with italic lowercase letters is an example of this kind of change. Originally, the capitals were written upright in the style of their inscribed forerunners, and the italic lowercase letters were written at a slant. As the practice of combining the styles continued, the capitals began to be written at the same slant as the italic, a modification that remains the prevalent form.

SPQR

The convention of using different alphabet styles for different functions or voices in the text is a firmly entrenched part of modern typography and graphic design. Indeed, adding more styles to a type family is a response to the desire for more voices on the typographic stage – a larger cast of characters for helping breathe life into a text. The members of a family are intended to be used together in order to provide the typographer with sufficient typographic variation in weight, condensation, and so on for the particular task at hand. Of course, not every member of a family is necessarily intended to have a part in every document. Both historically and today, the type designer's goal is to achieve a balance between the distinctiveness of individual members of a typeface and uniformity in the family as a whole.

Again, italic letters provide a good example. In order to perform their role, they must be clearly distinct from the roman design, having their own character but remaining compatible. The slope and condensation of most italic typefaces give them a different rhythm and texture than their upright companion. They maintain compatibility by being similar to the roman face in height and weight and other more subtle design features.

Perhaps the most frequently used combination of typefaces from different families is that of serif and sans serif. In the twentieth century, several type families have been designed with compatible serif and sans serif designs. They include Jan van Krimpen's Romulus, Gerard Unger's Praxis and Demos, Ed Benguiat's Benguiat and Benguiat Gothic, and the Lucida family

designed by Chuck Bigelow and Kris Holmes. The Stone family consists of Serif, Sans, and a third subfamily, the Informal.

Serif typefaces represent the most direct link with the letterforms that were in use when movable type was invented. Serifs first appeared as part of the Roman inscription capital letters. According to one theory, the serifs were the product of a natural brush movement for cleanly removing the brush from the stone. A more prevalent view – held by many stonecutters – is that the serifs were the product of a slightly exaggerated but very natural process of making a corner with the chisel. Whatever their origin, serifs are clearly an integral part of Roman capital letterforms.

In the late fifteenth century, Venetian punchcutters grafted the serifs from the Roman capital letters onto the feet of many lowercase forms, replacing a simpler penwritten stroke ending. Five hundred years later, the serif typefaces remain relatively unchanged. Readers greatly prefer these typefaces for reading long passages of text, although the reasons for their preference are unclear. Explanations that have been offered range from scientific investigations of legibility to speculations about the serif "leading the eye along the reading line." Whatever the reason, serif typefaces carry with them the great weight as well as the great momentum of the literary tradition of the Western world.

Sans serif letterforms have a less continuous tradition. They were carved in simple elegance in the inscriptions of the ancient Greeks. Their modern use can be traced to late eighteenth-century sign painting; the first example of a sans serif typeface appeared in the early nineteenth century. Sans serif typefaces were part of the explosion of letterform experiments that occurred with the beginning of the advertising age. Like the eucalyptus tree in California, they have been vigorous transplants. They are the unquestionable champions of the nineteenth-century efflorescence of letterforms. In the twentieth century, they became an integral part of design movements (such as the Constructivists and the Bauhaus) in search of an untraditional, purely functional look.

At the end of the millennium, we no longer need to view the sans serif form through any ideological glasses in order to assess its importance. It holds a major place in our visual vocabulary, linked with no-nonsense functionality, lack of adornment, and practicality. Its use connotes a detachment or even a disengagement from traditional culture. The twentieth century is arguably the century of the sans serif.

Informal typefaces are part of a third tradition, that of personal or informal writing. Since Roman times the letterforms used for writing personal communications – letters, lists, minutes of meetings, bills of sale, and so on – have had a different character from those used in formal writing. Written freely, sometimes whimsically, with a stylus on wax tablets or a pointed reed pen on papyrus, the Roman cursive stands at the beginning of two thousands years of informal writing.

The first practical technology for producing informal writing with a machine was the typewriter, which directly affected letterforms because of the severe constraints it placed on their design. The letters had to fit on metal hammers of uniform width. Every character had to have the same width. Designing these monospaced letterforms required a significant deformation in both wide and narrow characters. The *i*, *l*, *m*, and *w* suffered, as did the reader.

I designed the Stone typefaces to integrate these three different letterform styles – serif, sans serif, and informal – into one large, unified family. As the examples included in "Working with Stone" will demonstrate, many kinds of typography produced today can benefit from the use of such a comprehensive family.

acfry

When we speak, we generally do not consider the sounds of the words we are saying to be an important component in the process (with the notable exception of poetry and song). Similarly, in written language we generally do not compose words and sentences with any particular regard for their visual qualities. Nevertheless, our ability to read words, phrases, and sentences depends on the visual sense they make. Characters occur in visually arbitrary combinations. They must have coherence and integrity; they must be distinct but related. This is particularly true of type-faces that are intended to be used for setting large amounts of text. It is less true of typefaces that are going to be used for display, in which case an unusual-looking, even quirky, typeface may be advantageous because it attracts attention.

Earlier I mentioned the need for a type family to have a certain balance between variety and uniformity – an outgrowth of the structure of the family, which binds the individual members together and makes them work as a whole. Each formal alphabet style has both an outer and an inner structure. The outer structure is based on distinctive shapes, which are defined by such elements as serifs, bowls, joins, and arches. These shapes include not only the black strokes but also the equally important white counterspaces. Sometimes shapes are repeated as precise copies, but more frequently small variations are needed in these repeated shapes in order to make the individual letterforms work together in a satisfying and comfortable rhythm. These variations must be a balanced part of an organic whole, avoiding both monotony and chaos.

The inner structure of typefaces is harder to describe. It involves the strong connection that exists between the rhythms of the writing hand and the rhythms of the reading eye – one of the many mysteries to be found in letterforms. The "writing hand" at the core of the inner structure is that of the calligrapher, whose craft preceded type design. To a calligrapher, the primary component of letters is movement. The fundamental structure of any particular style consists of the constellation of kinesthetics (the internal physiological feelings) of the fingers, hand, wrist, and arm in making the strokes for each letter. Each alphabet has its own rhythmical pattern. Each individual character is a variation on a basic dance step. These different patterns are strung together into a complex choreography of words, sentences, paragraphs, and pages.

The calligrapher's tool itself – the broad-edged pen or brush – imposes its identity on the letterforms and has a strong unifying effect. By contrast, imagine an alphabet in which each letter was made with a different size or kind of writing tool! Using a single tool in a rhythmical fashion to write all the letters produces a visual uniformity that we can see in the spacing between strokes, the patterns of the branching, the stroke beginnings and endings, and many other features.

When the edged pen was superseded in the fifteenth century by movable metal type, the scribe's dance of the pen was replaced by the punchcutter's minute sculpting of the steel punch. Nonetheless, the first versions of these steel letters imitated handwritten forms with great faithfulness. A generation passed before Nicolas Jenson and Francesco Griffo began the process of judicious departures from penwritten forms that has continued into the present day. In the twentieth century, designers have generally eschewed the broad-edged pen for doing their preliminary drawings, preferring instead pencil, pointed brush, ballpoint pen, felt-tip pens, ruling pens, and other tools. (Designers like Rudolf Koch, Frederic Warde, F. H. E. Schneidler, Hermann Zapf, and G. G. Lange, who have drawn typefaces that are closely based on penwritten forms, may be exceptions to this rule.) Yet all of the departures of the past five hundred years have produced relatively small changes, at least for text typefaces. The remnants of the underlying rhythmical structure of written letterforms are still with us in modern letterform design, fundamentally influencing the personality of alphabet styles. This influence is most apparent in the typefaces that we are willing to read for extended periods of time, for instance in books, newspapers, and journals.

The work of sculpting metal characters by hand with gravers and small files continued from the middle of the fifteenth century until the nineteenth century, when the Benton pantograph machine was invented. With this machine an operator could use a large brass template of a letterform as a guide for manipulating the cutters that routed out the steel punch through a reduction mechanism. Cutting punches became an industrial process rather than a craft. Manual punchcutting has survived through most of the twentieth century only because of the persistence of a few stubborn practitioners.

Pantograph machines also made possible the production of many more typefaces for the newly invented mechanical typesetting machines, the most commercially successful of which were the Linotype and Monotype. This technology lasted for approximately a hundred years, until it was supplanted in the 1960s by photographic typesetting. A skilled draftsperson would carefully ink character images onto paper or cut them from a thin sheet of masking material. The characters would then be placed in a grid and photographed to produce a small piece of film that was put in the typesetting machine. Light was flashed through the film onto another piece of photographically sensitized paper or film, and in this way the characters were typeset.

Phototypesetting enjoyed only a brief currency before giving way to digital typesetting. Using characters in the form of computer programs or data, computers control a laser beam, cathode-ray tube, or other digital device capable of producing images composed of a large array of small dots (called pixels, from "picture elements"). The number of dots per linear inch determines the resolution, or imaging quality, of the output device: the higher the resolution, the more refined the image will be.

These dots have become to typographers what atoms were to scientists in the nineteenth century and before. They are the basic, irreducible building blocks out of which letterforms (and images in general) are composed. When the dots are large, as for example on a computer screen, they leave a very strong identifying mark. This digital look was exploited by a few artists and designers early in the history of digital imaging and has now become part of our visual culture. When the dots are made small enough, they become indistinguishable as dots and are no longer a factor in design.

Before personal computers came into general use in businesses, schools, and homes, a vast technological chasm separated the machines used for producing informal, personal documents, namely typewriters, and the machines used by the printing and publishing industry for setting type for formal purposes. Graphic designers have never considered the distinctive monospaced typewriter letterforms to be "real" type. A typewritten manuscript became a true typographic document only by the transforming agency of the typesetting house. Now these two historically separate worlds of typography have merged. The same personal computers are used for creating both informal and formal written communications; a letter and a book can be produced on the same machine. The same typefaces work on all of the machines, from computer screens with very low resolution to color thermographic printers and sophisticated laser typesetters. We have only recently begun to realize the far-reaching implications of this technological change.

**Type Design
on the Screen**

When I began designing the Stone typefaces in 1984, the Macintosh computer was in its infancy, the Apple LaserWriter printer (the first product to contain Adobe Systems' PostScript software) had not yet been announced, and there were no sophisticated object-oriented drawing programs such as Adobe Illustrator available on personal computers. I started drawing with a pencil and paper. First I drew about a hundred characters, each with a lowercase letter height of approximately one inch. I had these characters photographically enlarged to six times their original size, and then made precise redrawings by hand. These large pencil drawings were then digitized by plotting many points along the outline of a character with a digitizing tablet. The coordinates of these points were stored in the computer and used to produce a representation of the character made up of Bézier "splines" – a compact and efficient mathematical expression for curves.

From the original one hundred pencil-drawn characters, now manipulable in computer form, the entire typeface grew. Thanks to the remarkable elasticity of the Bézier curves and special software for modifying them, I was able to treat these first outlines like digital lumps, interactively molding them on the computer screen into other letterforms. The lump method allowed me to move, delete, or add to existing points on the Bézier curves and to pull and stretch existing shapes either in part or wholly. Sometimes the changes were very subtle, resulting in only a slight modification of existing shapes; at other times the changes were drastic.

There is no magic in this use of the computer to design letterforms. The computer does not draw the letters for us. Hard-won lettering skills must still be employed with this new tool. Yet the computer offers the great advantage of directness. In working on the computer screen, once again the designer is making the type itself, not a drawing that someone else will translate into type. We have our hands directly on the medium, just as the punchcutter did when engraving steel punches.

Another outstanding feature of the computer is that it allows us to produce very quickly many versions of the form or image we are designing. Type designers hunger for iteration. Again, the comparison with punchcutters is apt. A punchcutter was able to make an instant proof of the current state of a letter. By holding it over the flame of a candle to accumulate carbon and then pressing it onto paper, the punchcutter could obtain an impression of the letter that was very close to the one that would appear on the printed page. Each such "smoke proof" would bring a welcome view of the letter being sculpted. The computer offers a similar opportunity for corrections and frequent viewing, but the correction process is many times faster.

Graphic designers who work on the computer also like its iterative capacity and can take advantage of it to create many design variations for any given problem. Exploring different solutions is a normal part of the graphic design process, and the ability to produce these variations with a computer provides designers with a quicker, cheaper, and more accurate view of the potential final result.

The computer is also important in allowing us to track small differences in the letterforms being developed, and to assess their impact. The choice between longer or shorter serifs, lighter or heavier main strokes may be measured in thousandths or ten thousandths of an inch. Such small differences are significant for type designers because they are repeated over and over again – hundreds, thousands, even millions of times in text. Any conspicuous detail will be magnified many times by this repetition. With the computer we can make small adjustments and immediately see their effect by setting blocks of text in which the letterforms are repeated over and over again, in this way simulating the actual use that typographers will make of them.

The type designer has unquestionably been empowered by computer technology. In every way, the process of making typefaces, like the process of using them, has been made much more accessible. The technology continues to be improved. Software for designing typefaces on personal computers is very sophisticated and much more widely available than when I began designing type on the computer.

The technology of personal computers has also had a dramatic influence on the business of typefounding. Until recently, typeface manufacturing was controlled by the companies that manufactured and sold typesetting machines. All of the typefaces available for a given machine had to be made and distributed through the machine manufacturer. This is no longer true. Anyone with a personal computer, a laser printer, some software, and letter-drawing skills can be in the typefounding business. Fonts made for the personal computer will work on a large variety of machines made by different manufacturers. Small independent typefounding businesses, all but extinct in the twentieth century, are already experiencing a renaissance.

Working with Stone

Working with Stone

As typographers, we wish to "speak" clearly with typefaces – to communicate the writer's message accurately and directly. To do so we must understand the needs of our readers, which vary widely. The reader of a dictionary, for instance, has needs that are quite different from those of the reader of a novel or of someone who is just entering the perimeter of a park or a public building. To begin making a piece of typography, then, we must find answers to some basic questions about needs and uses: What is the message? Who is the intended audience? How long is the text and how is it organized? How many people will be using the piece and what will they be doing with it? What is its physical structure? How is it going to be produced? What kind of materials are going to be used? How will it be bound, folded, mounted, installed? How will it be packaged, distributed, and handled? How long is it supposed to last? How much will it cost?

Even the most basic typographic decisions – about which typefaces, sizes, leadings, line lengths to use – depend on the answers to these questions. Very small differences must be considered. The effect of using 9½-point instead of 10-point type, a slightly longer or shorter line length, or 1 point more or less space between lines may seem inconsequential, but each small increment is repeated over and over. The cumulative rhythm of these choices forms the personality of the typographic design, making it legible or illegible, light or dark, active or static, playful or serious. Developing a sensitivity to the effects of these small choices is part of becoming a typographer.

This is not a how-to book. Rather, the examples and commentaries contained in this section are intended to serve typographers and graphic designers as a window onto the typographic stage. Although only the Stone typefaces are shown, the examples address and solve many different design problems, and their solutions provide information about the uses of typefaces in general.

In the commentaries accompanying the examples, I offer some of my thoughts about the designs and the use of the Stone typefaces in them. In the "Design Notes," Brian Wu shares some of his thoughts about the design process. A list of type specifications at the end of the book (pages 107 and 108) describes in detail the choices that were made for each example.

On the facing page is a showing of the lowercase alphabets for all eighteen of the Stone typefaces – the raw material that has been used to compose the examples that follow. These typefaces can be combined in many ways, but only some combinations are appropriate for any given task. This section contains some excellent examples of appropriate combinations.

Medium	Serif	abcdefghijklmnopqrstuvwxyz
	Sans	abcdefghijklmnopqrstuvwxyz
	Informal	abcdefghijklmnopqrstuvwxyz

Medium Italic	*abcdefghijklmnopqrstuvwxyz*
	abcdefghijklmnopqrstuvwxyz
	abcdefghijklmnopqrstuvwxyz

Semibold	**abcdefghijklmnopqrstuvwxyz**
	abcdefghijklmnopqrstuvwxyz
	abcdefghijklmnopqrstuvwxyz

Semibold Italic	***abcdefghijklmnopqrstuvwxyz***
	abcdefghijklmnopqrstuvwxyz
	abcdefghijklmnopqrstuvwxyz

Bold	**abcdefghijklmnopqrstuvwxyz**
	abcdefghijklmnopqrstuvwxyz
	abcdefghijklmnopqrstuvwxyz

Bold Italic	***abcdefghijklmnopqrstuvwxyz***
	abcdefghijklmnopqrstuvwxyz
	abcdefghijklmnopqrstuvwxyz

Information Design

Information design – the typographic organization of large bodies of information with many levels and groupings – demands a large palette of typefaces. Such bodies of information are frequently found in books; in the computer world they are called databases. Whether on paper or on a computer screen, the first task is navigation – finding our way. We should not have to scan through an undifferentiated gray mass for the particular item we are seeking. If the information itself is well organized, with proper typographic differentiation we should be able to find our way quickly and easily to our destination.

The use of different styles of typefaces for different functions is a common way of providing navigational aids for readers. It is not surprising, then, that the examples in this section make the broadest use of the different members of the Stone typeface family. For instance, the travel-guide example on the facing page uses seven of the eighteen typefaces. In designing the Stone typefaces I wanted to create a family that would have a wide range of styles with underlying unity. The goal was to be able to combine many styles if necessary and still maintain visual coherence.

The travel guide provides a clear hierarchy of textual information – city name, map location, points of interest, descriptions, points of interest within descriptions, touring tips. This hierarchy is reflected in the structure

of the typography. The map presents some especially interesting problems in that the placement of the names of streets, buildings, sections, and such is dictated by geography rather than any predetermined typographic rules. Note the letterspacing of the Serif capitals used for district names.

Design Notes: There should be a balance between differentiation and uniformity. I could have used a different font for each kind of information, but this isn't necessary for communicating clearly, nor is it desirable aesthetically. Too many fonts or sizes can overwhelm both the eye and computer and printer memory. Try to do more with less.

Hierarchies in the text are established not only with the type, but also with the line spacing between paragraphs, sections, and so on. I like to limit the kinds of line spacing to multiples of half of the leading. For instance, I might use half-line spaces between paragraphs, and whole-line or one-and-a-half-line spaces to separate larger groupings of text.

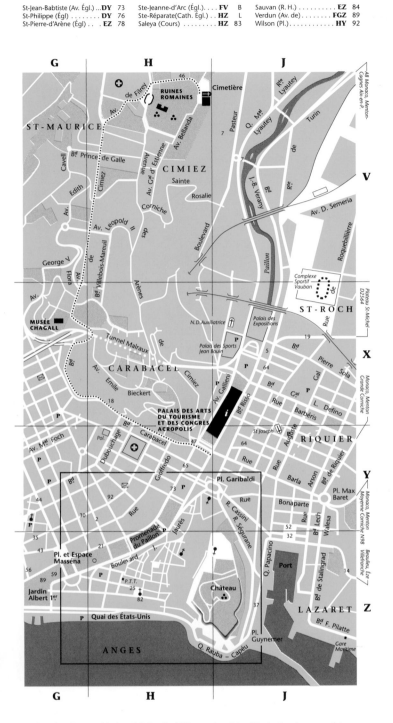

University Centre, National School of Dècorative Arts, Music Academy and important museums to add to the cultural life.
With its Exhibition Centre (20 000 places), its brand new Conference and Arts Centre and its many hotels, Nice remains the foremost tourist town in France and thereby gains its living.

Tour. *Allow a whole day to visit Nice; tour the sea front and the old town in the morning and Cimiez in the afternoon. Tourists with more time to spare are recommended to visit the Fine Arts Museum (p.206).*

** THE SEA FRONT *time 3/4 hour*

Place and Espace Masséna (KQR) – Begun in 1815 in the Italian style, the buildings form an architectural unit in red ochre with arcades at street level. A fountain stands in the southern section: four bronze horses rising from the basin.
The north side of the square opens into Avenue Jean-Médecin (formerly Avenue de la Victoire), which is the main shopping street, crowded with people and traffic. To the west extends what the 18C English called Newborough. Rue Masséna and Rue de France, its continuation, form the axis of a pedestrian precinct; here are smart shops, cinemas, cafés and restaurants between the tubs of flowers; it is a pleasant place to stroll at any hour of the day.
Avenue de Verdun skirts the **Albert I Garden (GZ)**, a welcome oasis of greenery surrounding a fountain: the three Graces, sculpted by Volti. It is the starting point for tours by two small **tourist trains**.

Promenade des Anglais (EFZ) – This wide and magnificent promenade, facing due south and bordering on the sea for its entire length, provides wonderful views of the Baie des Agnes, which extends from Cape Nice to the Fort Carré at Antibes. Until 1820, access to the shore was difficult, but the English colony, numerous since the 18C, undertook the construction of a coastal path which was the origin of the present promenade and gave it its name.
The famous Promenade has retained a sort of splendor despite being taken over by motor vehicles. The white stone and glass façades of the north side overlooking the sea still attract the visitor: Ruhl Casino and Hotel Méridien (1973), Palais de la Méditerranée – a fine example of 1930s architecture, the Negresco – a baroque structure dating from the Belle Époque (*c* 1900) and the Masséna Museum.

Quai des États-Unis (GHZ) – The eastern extension of the Promenade des Anglais passes **Les Ponchettes Gallery (KR:Y)** and the **Contemporary Art Gallery (KLR:X)**, which put on interesting temporary exhibitions.

* OLD NICE *time 3 hours*

The castle, Place Garibaldi, and the hanging gardens where the Paillon river has been covered over define the limits of the old town, which forms a network of twisting narrow lanes and steps on the lower slopes below the castle. The tall houses, bright with flowers or washing, exclude the glare of the sun and keep the streets cool. The many small shops, particularly near Boulevard Jean-Jaurès, the bars and the restaurants serving local dishes attract an endless flow of people to the district.
The western section, near the former Government Office and the Town Hall, was laid out in 17C on the grid pattern.

Park the car at the end of the Quai des États-Unis to walk up to the castle. Take the lift – the entrance is to the left of the 400 steps which also lead to the castle. Follow the arrows slightly downhill to visit the Naval Museum.

Naval Museum (LR:M3) – The Museum is at the top of the Bellanda Tower, a huge 16C circular bastion where Berlioz once lived for a while. At the entrance are two 17C Portuguese bronze cannons. Inside are models of ships, arms and navigation instruments. The walls are decorated with views of old Nice; a model shows the port at different periods in its history.

Castle (LR) – "Castle" is the name given to the 92 m – 300 ft high hill, arranged as a shaded walk, on which Nice's fortress once stood. Catinat blew up the powder magazine in 1691 and the fortress itself was destroyed in 1706 by Marshal de Berwick (1670 – 1734), the illegitimate son of James II who served in the French army.
From the wide platform on the summit there is an almost circular **view** *(viewing table)*. Below the terrace is an artificial waterfall fed by water from the Vésubie. On the eastern side the **foundations of an 11C cathedral** (apse and apsidal chapels) have been uncovered. Below these ruins a Roman level and a Greek level have been excavated.
Walk around the ruins. From the northwest corner of Castle Hill *(follow the arrows to "Cimetière, Vielle Ville")* there is a path affording bird's eye **views** of the roofs of old Nice and the Baie des Anges. Steps lead down near a chapel on the left.

Church of St Martin and St Augustine – (LQ:D) In this, the oldest parish in Nice, Luther, who was an Augustinian monk, celebrated mass in 1510, and Garibaldi was baptised. The church has a fine Baroque **interior** with a *Pietà*, the central panel of an altarpiece by Louis Bréa, on the left in the choir.
Outside and opposite the entrance is a **monument** erected in 1933 to Catherine Ségurane **(LQ:E)** (p.100).

Place Garibaldi (LQ) – The square was laid out at the end of the 18C in the Piedmont Style, the buildings coloured yellow ochre. It marks the northern limit of the old town and the beginning of the new. A statue of Garibaldi stands squarely among the fountains and greenery. **Holy Sepulchre Chapel (LQ:F)** on the south side of the square belongs to the brotherhood of Blue Penitents; it was built in 18C with a Baroque interior.
Rue Pairolière, a shopping street, passes St. Francis' bell-tower, part of a Franciscan convent which moved to Cimiez in 16C.

Place St-François (LQ:69) – A fish market is held here in the mornings round the fountain. To the right is the Classical façade of the former town hall now the Labour Exchange.
Fixed to a house on the corner of Rue Droite and Rue de la Loge is a cannon ball which dates from the siege of Nice by the Turks, allies of François I (1543).

Palais Lascaris (LQ:K) – The palace was built in Genoese style, influenced by local tradition, between 1643 and 1650 by the Count of Vintimiglia whose family was allied with the Lascaris, emperors of Nicaea in Asia Minor in 13C. The façade is decorated with balconies supported on consoles and columns with flowered capitals; scrollwork ornaments the doorway.

Average Daily Maximum & Minimum Temperature (°C)								
city	January		April		July		October	
	max	min	**max**	min	**max**	min	**max**	min
Nice	**16**	4	**20**	12	**26**	18	**21**	13
Bordeaux	**16**	14	**17**	14	**20**	17	**17**	14
Nantes	**15**	13	**18**	15	**21**	18	**18**	15
Paris	**13**	2	**18**	11	**25**	20	**19**	12
London	**6**	–1	**12**	6	**17**	13	**12**	7

of numerous usually small freshwater and marine fishes of the family Gobiidae, having the pelvic fins united to form a sucking disk. [Lat. *gobius* gudgeon < Gk. *kōbios*.]

go-by (gō′bī′) *n. Informal.* An intentional slight; snub.

go-cart (gō′kärt′) *n.* **1.** A small wagon for children to ride in, drive, or pull. **2.** A small frame on casters designed to help support a child learning to walk. **3.** A handcart. **4.** A stroller.

god (gŏd) *n.* **1.** *God.* **a.** A being conceived as the perfect, omnipotent, omniscient originator and ruler of the universe, the principal object of faith and worship in monotheistic religions. **b.** The force, effect, or a manifestation or aspect of this being. **c.** *Christian Science.* "Infinite Mind; Spirit; Soul; Principle; Life; Truth; Love" (Mary Baker Eddy). **2.** A being of supernatural powers or attributes, believed in and worshiped by a people, esp. a male deity thought to control some part of nature or reality. **3.** An image of a supernatural being; idol. **4.** Something that is worshiped or idealized: *money was his god.* **5.** A man of great beauty. [ME < OE.]

God-aw-ful (gŏd′ô′fəl) *adj. Slang.* Extremely trying; atrocious.

god-child (gŏd′chīld′) *n.* A person for whom another serves as sponsor at baptism.

god-daugh-ter (gŏd′dô′tər) *n.* A female godchild.

god-dess (gŏd′ĭs) *n.* **1.** A being of supernatural powers or attributes, believed in and worshiped by a people. **2.** An image of a supernatural being; idol. **3.** Something that is worshiped or idealized. **4.** A woman of great beauty or grace.

go-dev-il (gō′dĕv′əl) *n.* **1.** A logging sled. **2.** A railway handcar. **3.** A jointed tool for cleaning an oil pipeline and disengaging obstructions. **4.** An iron dart dropped into an oil well to explode a charge of dynamite.

god-fa-ther (gŏd′fä′thər) *n.* A man who sponsors a person at baptism.

god-for-sak-en also **God-for-sak-en** (gŏd′fər-sā′kən) *adj.* **1.** Located in a dismal or remote area. **2.** Desolate; forlorn.

god-head (gŏd′hĕd′) *n.* **1.** Divinity; godhood. **2.** *Godhead.* **a.** God. **b.** The essential and divine nature of God, regarded abstractly. [ME *godhede* : *god,* god (< OE) + *-hede,* -hood.]

god-hood (gŏd′hŏŏd′) *n.* The quality or state of being a god; divinity. [ME *godhode* : *god,* god (< OE) + *-hode,* -hood.]

god-less (gŏd′lĭs) *adj.* Recognizing or worshiping no god. —**god′less-ly** *adv.* —**god′less-ness** *n.*

god-like (gŏd′līk′) *adj.* Resembling or of the nature of a god or God; divine. —**god′like′ness** *n.*

god-ling (gŏd′lĭng) *n.* A minor god.

god-ly (gŏd′lē) *adj.* **-li-er, -li-est.** **1.** Having great reverence for God; pious. **2.** Divine. —**god′li-ness** *n.*

god-moth-er (gŏd′mŭth′ər) *n.* A woman who sponsors a person at baptism.

god-par-ent (gŏd′pâr′ənt, păr′-) *n.* A godfather or godmother.

God's acre *n.* A churchyard or burial ground. [Transl. of G. *Gottesacker.*]

god-send (gŏd′sĕnd′) *n.* Something wanted or needed that comes or happens unexpectedly. [ME *goddes sand,* God's message : *god,* God + *sand,* message < OE.]

god-son (gŏd′sŭn′) *n.* A male godchild.

God-speed (gŏd′spēd′) *n.* Success or good fortune. [From the phrase *God speed you.*]

god-wit (gŏd′wĭt′) *n.* Any of various wading birds of the genus *Limosa,* having a long, slender, slightly upturned bill. [Orig. unknown.]

goe-thite (gō′thīt′, gœ′tīt′) *n.* A brown mineral, essentially HFeO₂, used as an iron ore. [After Johann W. *von Goethe* (1749–1832).]

go-fer also **go-fer** (gō′fər) *n. Slang.* An employee who runs errands in addition to regular duties. [Alteration of *go for,* from that person's having to go for or after things.]

gof-fer also **gauf-fer** (gŏf′ər, gô′fər) —*tr.v.* **-fered, -fer-ing, -fers.** To press ridges or narrow pleats into (a frill, for example). —*n.* **1.** An iron used for goffering. **2.** Ridged or pleated ornamentation produced by goffering. [Fr. *gaufrer,* to emboss < OFr. *gaufre,* honeycomb < MLG *wāfel.*]

go-get-ter (gō′gĕt′ər) *n. Informal.* An enterprising, hustling person.

goggle (gŏg′əl) *v.* **-gled, -gling, -gles.** —*intr.* **1.** To stare with wide and bulging eyes. **2.** To roll or bulge. Used of the eyes. —*tr.* To roll or bulge (the eyes). —*n.* **1.** A stare or leer. **2. goggles.** A pair of large, usually tinted spectacles with shielding side pieces worn as a protection against wind, dust, or glare. [ME *gogelen,* to squint.] —**gog′gly** *adj.*

gog-gle-eyed (gŏg′əl-īd′) *adj.* Having prominent or rolling eyes.

go-go also **go-go** (gō′gō′) *adj. Informal.* **1. a.** Of or pertaining to discotheques or to the energetic music and dancing performed at discotheques. **b.** Engaged to perform at a discotheque: *a go-go dancer.* **2.** Energetic; lively. **3.** Of, pertaining to, or engaging in a type of speculative and therefore risky stock-market operation: *a go-go fund.* [< À GOGO.]

Goi-del-ic (goi-dĕl′ĭk) *n.* A branch of the Celtic languages that includes Irish Gaelic, Scottish Gaelic, and Manx. —*adj.* **1.** Of or pertaining to the Gaels. **2.** Of, pertaining to, or characteristic of Goidelic. [< OIr. *Goidel,* Gael.]

go-ing (gō′ĭng) *n.* **1.** Departure: *comings and goings.* **2.** The condition underfoot as it affects one's headway in walking or riding. **3.** *Informal.* Progress toward a goal; heading. —*adj.* **1.** Working; running: *in going order.* **2.** In full operation; flourishing: *a going business.* **3.** Current; prevailing: *The going rates are high.* **4.** Available; to be found: *the best products going.*

go-ing-o-ver (gō′ĭng-ō′vər) *n., pl.* **go-ings-o-ver.** *Informal.* **1.** An examination; inspection. **2. a.** A severe beating. **b.** A severe reprimand.

go-ings-on (gō′ĭngz-ŏn′) *pl.n. Informal.* Proceedings or behavior, esp. when regarded with disapproval.

goi-ter also **goi-tre** (goi′tər) *n.* A chronic, noncancerous enlargement of the thyroid gland, visible as a swelling at the front of the neck, occurring without hyperthyroidism and associated with iodine deficiency. [Fr. *goitre* < Prov. *goitron* < Lat. *guttur,* throat.] —**goi′trous** (-trəs) *adj.*

Gol-con-da (gŏl-kŏn′də) *n.* A source of great riches, as a mine. [After *Golconda,* India.]

gold (gōld) *n.* **1.** *Symbol* **Au** A soft, yellow, corrosion-resistant element, the most malleable and ductile metal, occurring in veins and alluvial deposits and recovered by mining or by panning or sluicing. It is a good thermal and electrical conductor, is generally alloyed to increase its strength, and is used as an international monetary standard, in jewelry, for decoration, and as a plated coating on a wide variety of electrical and mechanical components. Atomic number 79; atomic weight 196.967; melting point 1,063.0°C; boiling point 2,966.0°C; specific gravity 19.32; valences 1, 3. **2. a.** Coinage made of gold. **b.** A gold standard. **3.** Money; riches. **4.** A light olive-brown to dark yellow or moderate, strong, to vivid yellow. **5.** Something regarded as having great value or goodness: *a heart of gold.* —*adj.* Having the color of gold. [ME < OE.]

gold-beat-er's skin (gōld′bē′tərz) *n.* Treated animal membrane used to separate sheets of gold being hammered into gold leaf.

gold-beat-ing (gōld′bē′tĭng) *n.* The act, art, or process of beating sheets of gold into gold leaf. —**gold′beat′er** *n.*

gold brick *n.* **1.** A bar of gilded cheap metal that appears to be genuine gold. **2.** A fraudulent and worthless substitute.

gold-brick *n.* (gōld′brĭk′) *Slang.* —*n.* A person, esp. a soldier, who avoids assigned duties or work; shirker. —*v.* **-bricked, -brick-ing, -bricks.** —*intr.* To shirk one's assigned duties or responsibilities. —*tr.* To cheat; swindle. —**gold′brick′er** *n.*

gold bug *n.* **1.** A North American beetle, *Metriona bicolor,* with a metallic luster. **2.** A supporter of the gold standard.

gold certificate *n.* A monetary note formerly issued to the public by the U.S. Treasury and redeemable in gold but now issued to Federal Reserve Banks to certify conformity with their legal reserve requirements.

gold digger *n. Slang.* A woman who seeks money and expensive gifts from men.

gold dust *n.* Gold in powder form.

gold-en (gōl′dən) *adj.* **1.** Of, pertaining to, made of, or containing gold. **2. a.** Having the color of gold or a yellow color suggestive of gold. **b.** Lustrous; radiant: *the golden sun.* **c.** Suggestive of gold, as in richness or splendor: *a golden voice.* **3.** Of the greatest value or importance; precious. **4.** Marked by peace, prosperity, and often creativeness: *a golden era.* **5.** Very favorable or advantageous; excellent: *a golden opportunity.* **6.** Having a promising future; seemingly assured of success: *a golden boy.* **7.** Of or pertaining to a

50th anniversary. —**gold′-en-ly** *adv.* —**gold′en-ness** *n.*

golden age *n.* **1.** *Gk. & Rom. Myth.* The first age of the world, an untroubled and prosperous era during which people lived in ideal happiness. **2.** A period of peace, prosperity, and happiness.

golden ager *n.* An elderly person, esp. one of retirement age.

golden Al-ex-an-ders (ăl′ĭg-zăn′dərz) *n. (used with a sing. or pl. verb).* A plant, *Zizia aurea,* of eastern North America, having clusters of small yellow flowers.

golden aster *n.* Any of various North American plants of the genus *Chrysopsis,* having yellow, rayed flowers.

golden bantam *n.* A variety of corn having large, bright-yellow kernels on a relatively small ear.

golden calf *n.* **1.** A golden image of a sacrificial calf fashioned by Aaron and worshiped by the Israelites. **2.** Money as an object of worship; mammon.

golden club *n.* An aquatic plant, *Orontium aquaticum,* of the eastern United States, having small golden-yellow flowers covering a clublike spadix.

golden eagle *n.* An eagle, *Aquila chrysaetos,* of mountainous areas of the Northern Hemisphere, having dark plumage with yellowish feathers on the head and neck.

gol-den-eye (gōl′dən-ī′) *n.* Either of two ducks, *Bucephala clangula* or *B. islandica,* of northern regions, having a short black bill, a rounded head, and black and white plumage. [From their golden-yellow eyes.]

Golden Fleece *n. Gk. Myth.* The fleece of the golden ram, stolen by Jason and the Argonauts from the king of Colchis.

golden glow *n.* A tall plant, *Rudbeckia laciniata hortensis,* cultivated for its yellow, many-rayed, double flowers.

Golden Horde *n.* The Mongol army that swept over eastern Europe in the 13th century and established a suzerain in Russia. [From the golden tent of their commander.]

golden mean *n.* The course between extremes.

golden oldie *n.* A recording, motion picture, or other form of entertainment that was very popular in the past.

golden pheasant *n.* A pheasant, *Chrysolophus pictus,* of China and Tibet, having a long tail and brilliantly colored plumage.

gold-en-rod (gōl′dən-rŏd′) *n.* Any of numerous chiefly North American plants of the genus *Solidago,* having clusters of small yellow flowers that bloom in late summer or fall.

golden rule *n.* The biblical teaching that one should behave toward others as one would have others behave toward oneself.

gold-en-seal (gōl′dən-sēl′) *n.* A woodland plant, *Hydrastis canadensis,* of eastern North America, having small greenish-white flowers and a yellow root formerly used medicinally.

golden section *n.* A ratio, observed esp. in the fine arts, between the two dimensions of a plane figure or the two divisions of a line such that the

Dictionary: A dictionary, like a travel guide, contains multiple levels of information. In this example, the use of the serif and sans serif typefaces in their different weights yields an integrated page that makes the different levels easy to find and their different designations clear. Note the use of the Sans Semibold for the numerals and letters introducing the different definitions for each word. If Serif Medium – the type of the definitions themselves – had been used instead, we would have a much harder time finding the beginning of the next most common definition, and would probably have to resort to reading or at least scanning the entire preceding definition.

Design Notes: Stone Serif Medium works well at a small size. The method of justification used in this example does not permit letterspacing to be greater than normal because the "blackness" of the bold main entries would be disturbed (some would be letterspaced and others not). Space is added between words only.

Programming Manual: Technical manuals offer a complex typographic challenge. The general issues are similar to those in other kinds of information design. Typographically it is important to set up conventions that the reader can consistently identify as indicating a certain kind of information. For example, in the manual shown here, the names of commands in the PostScript programming language – the subject of the manual – are set in Serif Semibold throughout the book. The computer listings are set in Informal, replacing the monospaced typewriter type in which such listings are commonly set. This is one of the uses I had in mind for the Informal as I was developing it.

The PostScript manual, like the travel guide, shows all three main divisions of the Stone family – Sans, Serif, and Informal – being used together.

Design Notes: Here, the nature of the text determines the form. Code listings are usually narrow, and the narrow format saves paper. "Wire-O" or spiral binding is best for getting a book to lie flat when open.

Periodic Table (pages 26 and 27): The overall structure and texture of the chart depend greatly on the feeling of the letterforms. The large type designating the elements has an abstract graphic quality that is enhanced because the combinations of letters are unfamiliar (except to a chemist or physicist); we are less caught up in the meaning than usual.

Design Notes: Not many styles are needed because the bits of information in each cell are easy to distinguish even in the absence of variations in typographic style. The outline type for Unp and Unh is a graphic translation of the fact that these two elements do not yet have official names. Since they don't have solid names, they don't get solid type.

invoking a printer-specific feature like manual paper feed or a particular paper tray will not work on a printer which does not offer that feature. A simple mechanism to avoid this is to use the **known** operator to check for the existence of the operator before you use it:

```
statusdict /ledgertray known { %ifelse
    statusdict begin
        ledgertray
    end
}{ %else
    90 rotate 0 –612 translate
    612 792 div dup scale
} ifelse
```

This tests to see if the **ledgertray** operator exists in statusdict. If it does, it is invoked. If it does not, then the standard letter-size page is placed into landscape mode and scaled down to simulate the layout of **ledgertray**. The **where** operator may also be used in a similar fashion.

Implementation Limits Exceeded

A **limitcheck** error can arise if an internal limitation has been exceeded by a user program. This can occur, for instance, when using **clip**, **charpath**, or **flattenpath**. These operators are all sensitive to the *resolution* of the PostScript device to some extent. Both **clip** and **charpath** provide a *flattened* path, which means that all curve segments in the path are reduced to line segments. The current **flatness** affects the closeness of the approximation. There will typically be many more line segments when flattening a path on a high resolution device than on a low resolution device. For example, *figure 14.1* shows a curved path stroked first with gray at the normal flatness, then in black with a flatness of five user units (about 100 device units at 1270 dpi).

```
%!PS-Adobe-l .0
%%Title: logo procedure
%%EndComments
/logo { %def
    % draw at current point
gsave
    /Times-Roman findfont
    48 scalefont setfont
    (G) show –13.5 –14.5 rmoveto (R) show
grestore
–4 –8 rmoveto
/Helvetica findfont 11 scalefont setfont
(glenn) show 22 3 rmoveto (reid) show
} bind def
%%EndProlog
gsave
100 100 moveto logo
grestore
```

197 Error Handling

	1a	2a	3b	4b	5b	6b	7b	8

orbit

T R A N S I

H +1
1
1.00794±7
1

K

Li +1 **Be** +2
3 4
6.941±3 9.01218
2-1 2-2

K-L

Na +1 **Mg** +2
11 12
22.98977 24.305
2-8-1 2-8-2

K-L-M

K +1 **Ca** +2 **Sc** +3 **Ti** +2/+3/+4 **V** +2/+3/+4/+5 **Cr** +2/+3/+6 **Mn** +2/+3/+4/+7 **Fe** +2/+3
19 20 21 22 23 24 25 26
39.0983 40.08 44.9559 47.88±3 50.9415 51.996 54.9380 55.847±3
-8-8-1 -8-8-2 -8-9-2 -8-10-2 -8-11-2 -8-13-1 -8-13-2 -8-14-2

-L-M-N

Rb +1 **Sr** +2 **Y** +3 **Zr** +4 **Nb** +3/+5 **Mo** +6 **Tc** +4/+6/+7 **Ru** +3
37 38 39 40 41 42 43 44
85.4678±3 87.62 88.9059 91.22 92.9064 95.94 (98) 101.07±3
-18-8-1 -18-8-2 -18-9-2 -18-10-2 -18-12-2 -18-13-1 -18-13-2 -18-15-1

-M-N-O

Cs +1 **Ba** +2 **La** +3 **Hf** +4 **Ta** +5 **W** +6 **Re** +4/+6/+7 **Os** +4
55 56 57 72 73 74 75 76
132.9054 137.33 138.9055±3 178.49±3 180.9479 183.85±3 186.207 190.2
-18-8-1 -18-8-2 -18-9-2 -32-10-2 -32-11-2 -32-12-2 -32-13-2 -32-14-2

-N-O-P

Fr +1 **Ra** +2 **Ac** +3 **Rf** +4 **Unp** **Unh**
87 88 89 104 105 106
(223) 226.0254 227.0482 (260) (260) (263)
-18-8-1 -18-8-2 -18-9-2 -32-10-2 -32-11-2 -32-12-2

-O-P-Q

Ce +3/+4 **Pr** +3/+4 **Nd** +3/+4 **Pm** +3/+4 **Sm** +3
58 59 60 61 62
140.12 140.9077 144.24±3 (145) 150.36±3
-20-8-2 -21-8-2 -22-8-2 -23-8-2 -24-8-2

Lanthanides

-N-O-P

Th +4 **Pa** +4 **U** +4 **Np** +4 **Pu**
90 91 92 93 94
232.0381 231.0359 238.0289 237.0482 (244)
-18-10-2 -20-9-2 -21-9-2 -22-9-2 -24-8-2

Actinides

-O-P-Q

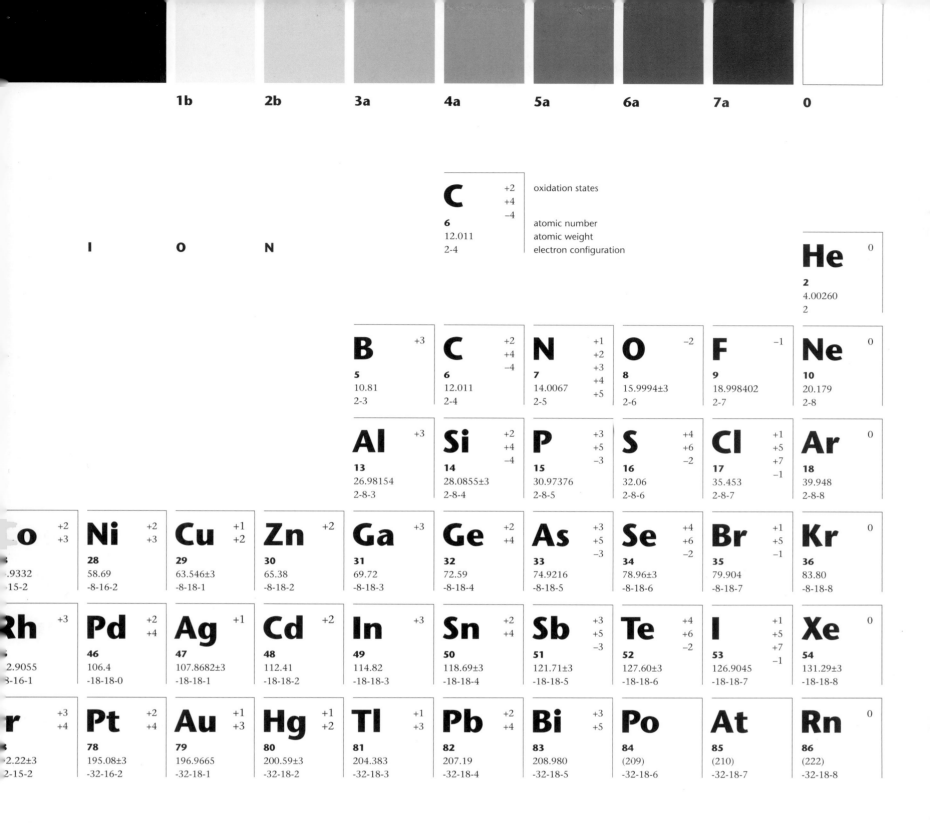

| 1b | 2b | 3a | 4a | 5a | 6a | 7a | 0 |

C +2 +4 −4 — oxidation states
6 — atomic number
12.011 — atomic weight
2-4 — electron configuration

I O N

He 0
2
4.00260
2

B +3
5
10.81
2-3

C +2 +4 −4
6
12.011
2-4

N +1 +2 +3 +4 +5
7
14.0067
2-5

O −2
8
15.9994±3
2-6

F −1
9
18.998402
2-7

Ne 0
10
20.179
2-8

Al +3
13
26.98154
2-8-3

Si +2 +4 −4
14
28.0855±3
2-8-4

P +3 +5 −3
15
30.97376
2-8-5

S +4 +6 −2
16
32.06
2-8-6

Cl +1 +5 +7 −1
17
35.453
2-8-7

Ar 0
18
39.948
2-8-8

o +2 +3
.9332
-15-2

Ni +2 +3
28
58.69
-8-16-2

Cu +1 +2
29
63.546±3
-8-18-1

Zn +2
30
65.38
-8-18-2

Ga +3
31
69.72
-8-18-3

Ge +2 +4
32
72.59
-8-18-4

As +3 +5 −3
33
74.9216
-8-18-5

Se +4 +6 −2
34
78.96±3
-8-18-6

Br +1 +5 −1
35
79.904
-8-18-7

Kr 0
36
83.80
-8-18-8

Rh +3
2.9055
8-16-1

Pd +2 +4
46
106.4
-18-18-0

Ag +1
47
107.8682±3
-18-18-1

Cd +2
48
112.41
-18-18-2

In +3
49
114.82
-18-18-3

Sn +2 +4
50
118.69±3
-18-18-4

Sb +3 +5 −3
51
121.71±3
-18-18-5

Te +4 +6 −2
52
127.60±3
-18-18-6

I +1 +5 +7 −1
53
126.9045
-18-18-7

Xe 0
54
131.29±3
-18-18-8

r +3 +4
2.22±3
2-15-2

Pt +2 +4
78
195.08±3
-32-16-2

Au +1 +3
79
196.9665
-32-18-1

Hg +1 +2
80
200.59±3
-32-18-2

Tl +1 +3
81
204.383
-32-18-3

Pb +2 +4
82
207.19
-32-18-4

Bi +3 +5
83
208.980
-32-18-5

Po
84
(209)
-32-18-6

At
85
(210)
-32-18-7

Rn 0
86
(222)
-32-18-8

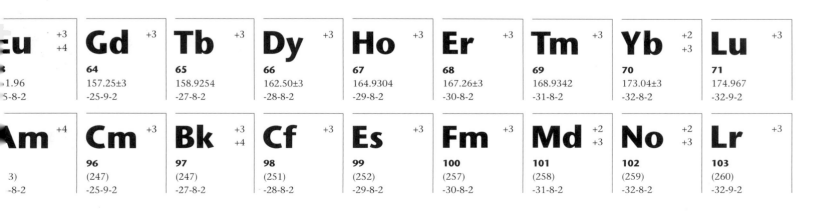

u +3 +4
1.96
5-8-2

Gd +3
64
157.25±3
-25-9-2

Tb +3
65
158.9254
-27-8-2

Dy +3
66
162.50±3
-28-8-2

Ho +3
67
164.9304
-29-8-2

Er +3
68
167.26±3
-30-8-2

Tm +3
69
168.9342
-31-8-2

Yb +2 +3
70
173.04±3
-32-8-2

Lu +3
71
174.967
-32-9-2

Am +4
3)
-8-2

Cm +3
96
(247)
-25-9-2

Bk +3 +4
97
(247)
-27-8-2

Cf +3
98
(251)
-28-8-2

Es +3
99
(252)
-29-8-2

Fm +3
100
(257)
-30-8-2

Md +2 +3
101
(258)
-31-8-2

No +2 +3
102
(259)
-32-8-2

Lr +3
103
(260)
-32-9-2

Books

Book design is unquestionably the most complicated and subtle task that a typographer faces. The different parts of a book provide a rich field of design possibilities. The cover; the copyright page, acknowledgments, table of contents, and other front matter; the main text and its potentially numerous elements; and back matter that can include appendixes, bibliography, index, and colophon – each of these parts has its own set of design issues to be dealt with, and the various parts must be integrated into a harmonious whole. As a consequence, the typographic structure of books can be extremely complex.

The navigational issues associated with information design apply to many books as well, and in fact all of the examples in the "Information Design" section are from books, with the exception of the periodic table of elements. Unlike reference books or manuals, however, most books contain long passages of text that are intended to be read continuously (that is, without skipping from one physical location in the book to another). The primary requirement for a book of this kind is that the text typeface be legible. It must be neither quirky nor monotonous. It must have an even and comfortable appearance in words, lines, and pages; recurring bumps or rough spots in the road are most unwelcome on a long journey. My goal in designing the Stone Serif Medium was to create a typeface that was suited for book-length continuous text.

The first book to be set in the Stone typefaces was called *Body & Soul*. Ironically, the letterforms used in the title on the cover (opposite) are not actually the Stone types. I redrew them on the computer specifically for use at the size and in the combinations in which they appear in the words *Body & Soul*. The ampersand is an interesting character in that it stands for an entire word, *et*, which means *and* in Latin. The character is a ligature – a joining together of the *e* and the *t*.

The practice of redrawing letterforms for book titles, inscriptions, mastheads for periodicals, logotypes, and other purposes is an aspect of the craft of lettering that is still carried on by a small but highly skilled group of professionals. Some people in our culture still appreciate that letters made to be reproduced by machine can never have as much character as those made by hand for a specific purpose. The more we know about the situation in which the letters will be used, the easier it is for us to make letters that are well suited to their environment.

BODY & SOUL

TEN AMERICAN WOMEN
CAROLYN COMAN & JUDY DATER

Ten Philosophers
of Æsthetics

An anthology of readings

from the works of

Plato, Aristotle, Shaftesbury

Plotinus, Kant

Augustine, Schelling, Hegel

Wilde & Heidegger

Edited by Gordon E. Twining

The Adobe Creek Press · 1987

Ten Philosophers: A certain tension exists between the Sans Semibold type, the Serif Medium Italic, and the ornamental leaf of the title page. Each represents a typographic style that has different cultural meanings and associations. The sans serif spells a break with tradition, the italic is based on fifteenth-century handwriting, and the ornament is part of a long tradition of printers' ornaments.

Design Notes: I tried to alternate long and short lines to make an interesting overall shape. In the chapter-opening page below, I repeated the centered style to be consistent with the title page.

Photography Book: The use of sans serif type for composing books with a lengthy text is unusual. To an extent the reluctance to set whole books in sans serif is due to the conservative nature of text typography. Legibility may also be an issue. I designed the Stone Sans typefaces to have an inner structure matching the highly legible Stone Serif types, hoping in this way to render the Sans useful for long passages of text by increasing their legibility.

Design Notes: Rule of thumb – make something either clearly symmetric or clearly asymmetric and then stick to it. White, or negative, space adds to the design when it has a definite shape. Hence the decision to push the single column of text to the right instead of to the left because of the ragged-right edge. Rag right can look very good if it is hand-tuned with manual line breaks and hyphenation to get long-short, long-short, and so on.

Martin Heidegger
The Origin of the Work of Art

Origin here means that from which and by virtue of which a thing is, what it is and how it is. That which something is, as it is, we call its essence. The origin of something is the source of its essence. The question concerning the origin of the work of art has to do with the source of its essence. On the usual view, the work arises out of and by means of the activity of the artist. But by what and whence is the artist what he is? By the work; for to say that the master is known by his work means that it is the work that first lets the artist emerge as a master of his art. The artist is the origin of the work. The work is the origin of the artist. Neither is without the other. Nevertheless, neither is the sole support of the other. In themselves and in their interrelations artist and work *are* always by virtue of a third thing which is first, namely by virtue of that which gives artist and work of art and their names, art.

Just as the artist necessarily is the origin of the work in a different manner than the work is the origin of the artist, so, in a still different way, art is all the more the origin of both artist and work. But can art be an origin at all? Where and how does art occur? Art – after all, this is only a word to which nothing real corresponds. It may pass for a collective idea under which we find a place for that which alone is real in art: works and artists. Even if the word were taken to signify more than a collective idea, what is meant by the work could only exist on the basis of the actuality of works

197

Quite often, though, removing
the lens cap proved very helpful.

The comment was made by
Felicia Menton about the
portraits of Wendy Ottomanelli
taken in September 1984.

I think that I will never be quite sure what a photograph is supposed to be, only more or less so. But I am beginning to approach an understanding of the thing by discovering what it is not. I embarked on this enterprise with a naive enthusiasm which dissolved into trepidation when, upon looking through the viewfinder, I could not see anything; that is to say, nothing that I had wanted or hoped to see.° I had no choice but to leap in and begin shooting. The initial result was that many pictures taken were bad both aesthetically and technically. But through examination of these directionless failures I was able to establish a point of view. I saw that I could actively start to *take* pictures, rather than catching one by chance, and establish a process of developing ideas which could feed upon itself. An idea could be utilized and investigated, or saved for another subject at a later time, or not. But each photo, to some extent, began to inform the next.

The resolution of a point of view about the pictures I was taking and about looking at pictures in general occurred at what I initially perceived as a setback. An offhand comment about some photographs of one of my classmates – that they were nice but didn't look like her – caused me to question exactly what I was doing and what I had gotten myself into.° I went back to the books on photography and photographers that I had been reading and looked closely at them again to find a clue to where I might have gone wrong.

What I discovered was the confirmation of an idea that had been forming in my mind for some time. That idea is this: that a picture has only little to do with a particular subject in a historical sense, but rather has to do primarily with the creation of a brand new being-in-the-world with its own particular characteristics, and its own history which begins "now." Of course a picture is always a picture of something and in a variety of contexts exists quite happily on that level. But it need not merely exist on that level; it can transcend the subject it records toward its new self as a unique object in the world. For in the end, a picture is an object, and it is necessary for one to resist saying only about a photograph "look at that person in that picture, see how high he can jump," as if one were looking at a real man in a small box. What we are concerned with is a two-dimensional thing that can be picked up and held – close or far away – a thing which has removed

The three pages of this book give us a notion of the complexity involved in designing academic material for publication. Chapter numbers and titles, topics and subtopics within chapters, quotations, and footnotes are some of the elements that we can see in this small sample of the book. Each needs to be distinguished typographically.

As in information design, the task is to make our job of navigating through the material as easy as possible. This is accomplished by making the typography an accurate reflection of the organization of the book's content while at the same time avoiding typographic distinctions that are extreme and therefore distracting. Because this example uses the Serif typeface throughout, variations in size become very important in differentiating the text elements: chapter number and title, the text, the quotation, the all-cap subheadings, and the footnotes are all different sizes. For each size of type, the leading has been adjusted so that the block of text has a vertical rhythm created by the spaces between lines that is similar to the rhythm of the type blocks at other sizes.

Design Notes: The large 6 is set in Serif Medium, while the chapter title is set in a smaller size of Serif Semibold. The effect of this inverted relationship of size and weight is to keep a consistent weight or blackness in the titling type. The same effect is achieved by the subheading set in small Serif Semibold capitals, which match the x-height and weight of the surrounding text type. Note that the footnote numbers extend into the margin; this makes the text of the footnotes align with the body text. Similarly, positioning the page numbers in the margin forces the running heads to align with the text.

6
The Turn of Dynastic Fortune: From Prosperity to Decline

We have noted that China before 1800 was a vast empire which stood resplendent and unrivaled in East Asia. Its territory stretched from the Central Asian massif to the coast of the China Sea, and from the Mongolian desert to the jungles and shores of the south. China in the middle 18th century was doubtless one of the most advanced countries on earth, and its secular political and social systems had won the admiration of not a few famous European philosophers.[1] But after 1775 the decline began to set in.

The Decline of the Manchu Power

When Emperor Ch'ien-lung abdicated the throne in 1795, the dynasty had already passed its apogee and the seeds of decay had long since been sown. His fifteenth son, who became Emperor Chia-ch'ing, inherited a country that was "externally strong but internally shriveled" (*wai-ch'iang chung-kan*). Indeed, Chia-ch'ing's twenty-five-year reign (1796-1820) was plagued with serious administrative, military, and moral problems which were unmistakable indices of the falling dynastic fortune.

ADMINISTRATIVE INEFFICIENCY. The suspicion which the Manchu court entertained toward Chinese officials and the resultant policy of mutual check undermined administrative efficiency. A noted contemporary political scientist has remarked on this crippling effect:

> Public functionaries were rarely given an opportunity to show initiative, independent judgment, or satisfactory performance of tasks through the exercising of adequate authority. On the contrary, all officials were subjected to a tight net of regulations, restriction, and checks, and threatened with punishment for derelictions or offenses even in matters beyond their individual control. A situation eventually prevailed in which the most prudent thing for the average official to do was assume as little responsibility as possible – to pay greater attention to formal compliance with written rules than to undertakings that were useful to the sovereign or beneficial to the people.[2]

1. Spinoza, Leibniz, Goethe, Voltaire, and Adam Smith.
2. Kung-ch'üan Hsiao, *Rural China*, 504.

Left page

The accuracy of this observation can be seen in a piece of advice given by K'ang-hsi himself to a governor in 1711: "Now that the country is at peace, it is advisable that you avoid trouble. An act that is beneficial in one way may be harmful in another. The ancients said, 'More commitment is not as good as less commitment.'"[3] Thus the guiding principle in the officialdom was to avoid issues. A highly placed courtier once confided that the secret of success in government was to "kowtow more and talk less." It is therefore understandable that there developed a tendency toward compromise, superficiality, temporization – anything so as not to disturb the *status quo*. That these characters strangled the capacity of officials for energetic action and imaginative response to challenge did not trouble the court, for its primary concern was not for dynamic or even efficient administration, but for the dynasty's security. Large decisions were not the province of administrators, but the prerogative of the emperor. Under these conditions the state prospered only in direct proportion to the emporor's capacity. Such a high concentration of power worked well with resourceful rulers such as K'ang-hsi, Yung-cheng, and Ch'ien-lung, but once leadership faltered, the ship of state drifted. After Ch'ien-lung, there was no great emperor.

WIDESPREAD CORRUPTION. The last twenty years of Ch'ien-lung's reign were very corrupt. Ho-shen, the imperial bodyguard whose meteoric rise to power was discussed in Chapter 2, bled the state for nearly a quarter of a century and amassed an incredible fortune of 800 million taels (about $1.5 billion), reputedly more than half the *actual* total state income for twenty years. The inventory of his estate revealed some interesting entries: 4,288 gold bowls and dishes, 600 silver pots, 119 gold wash basins, 5.8 million ounces of gold, 75 pawnshops with a capital of 30 million taels, 42 moneyshops with a capital of 40 million taels, and 800,000 *mou* of land at an estimated value of 8 million taels.[4] When Emperor Chia-ch'ing executed him in 1799, a popular saying circulated: "When Ho-shen fell, Chia-ch'ing feasted."[5]

It should be noted, however, that Ho-shen was an acute symptom rather that the cause of the widespread corruption, which was evident even before his rise. Nonetheless, he accentuated the trend and his evil influence continued to haunt the country. Graft, extortion, and irregular levies in both the civil government and the military services became commonplace, almost *de rigueur*. Metropolitan officials openly accepted "presents" from provincial officials, who in turn required them of their own subordinates. These officials led a way of life far beyond their salaries; many maintained luxurious residences with private staffs of servants, guards, and sedan-carriers, entertained permanent houseguests, and supported poor relatives. Their positions made demands

3. Wang Hsien-ch'ien, *Tung-hua lu* (Tung-hua records), K'ang-hsi, 50th year (1711), 18:2b, edict to Governor Fan Tsung-lo.
4. Hsiao I-shan, II, 264-67.
5. Actually only a small portion of Ho-shen's property was confiscated by the government and parceled out to the princes and nobles as gifts of the emperor. *Ibid.*, II, 268.

Right page

Act II Scene vii

ORLANDO

127 Then but forbear your food a little while,
Whiles, like a doe, I go to find my fawn
And give it food. There is an old poor man
Who after me hath many a weary step
Limped in pure love. Till he be first sufficed,
Oppressed with two weak evils, age and hunger,
I will not touch a bit.

 DUKE SENIOR

134 — Go find him out,
 And we will nothing waste till you return.

ORLANDO

135 I thank ye, and be blest for your good comfort! *[Exit.]*

 DUKE SENIOR

136 Thou seest we are not all alone unhappy:
 This wide and universal theatre
 Presents more woeful pageants than the scene
 Wherein we play in.

 JAQUES

139 — All the world's a stage,
 And all the men and women merely players;
 They have their exits and their entrances,
 And one man in his time plays many parts,
 His acts being seven ages. At first, the infant,
 Mewling and puking in the nurse's arms.
145 Then the whining schoolboy, with his satchel
 And shining morning face, creeping like snail
 Unwillingly to school. And then the lover,
 Sighing like furnace, with a woeful ballad
 Made to his mistress' eyebrow. Then a soldier,
150 Full of strange oaths and bearded like the pard,
 Jealous in honor, sudden and quick in quarrel,
 Seeking the bubble reputation
 Even in the cannon's mouth. And then the justice,
 In fair round belly with good capon lined,
155 With eyes severe and beard of formal cut,
 Full of wise saws and modern instances;
 And so he plays his part. The sixth age shifts
 In the lean and slippered pantaloon,
 With spectacles on nose and pouch on side;
160 His youthful hose, well saved, a world too wide

Shakespeare: The combination of Sans Semibold for the names of the players and Serif Medium for the text demonstrates one of the advantages of using the Stone family of typefaces. I designed the semibold in each of the three Stone subfamilies so that it was just heavy enough to be obviously bolder than the medium weights, even when used in small sizes and printed out on low-resolution laser printers. As a result, the semibold faces can serve to create clear but subtle distinctions. Moreover, the three medium weights have the same stem thickness, as do the three semibolds and the three bolds. The Sans Semibold shown in this example therefore has the same relationship to the Serif Medium and the Informal Medium as it has to the Sans Medium. Because of this correspondence, it is possible to combine the semibold or bold versions from any of the three subfamilies with the medium version of any other subfamily and still preserve the same relationship between the weights.

Design Notes: I could have "cast" Orlando in Serif, Jaques in Sans, and so on, but use of indentation works better. The typographic structure makes it easier for actors to find their parts while rehearsing, and people simply reading the script might be able to visualize the dialogue better because their eyes would have to shift from one character's "position" to another's.

Children's Book: The Informal typeface has been used in several children's books. One of my intentions in designing the Informal was to make shapes that were round, somewhat soft, open, and friendly. Sharp corners have been rounded off. I made the contrast between the thick and thin strokes less than in the Serif types in order to give the Informal a solid, comfortable appearance. It is perhaps these qualities that have made the typeface popular for children's books.

Design Notes: The Informal a and g are "one-story" versions, the way they're usually written with a pen. Perhaps this is a good visual lesson for young people just beginning to read and write. At any rate, there is a pleasant relationship between the letterforms, which come out of a hand-made tradition, and the hand-drawn illustration.

Art Center College of Design

34

Just then, Harry saw something wiggling in the sand.

He could not believe his eyes. It was a worm!

Periodicals

For me and for many other people, reading the morning newspaper is a ritual. Familiar typefaces greet me. I know where to look for my favorite cartoon, a columnist I follow, international news, reviews of movies and books, and so on. In general, periodicals are diverse in the information they carry, but their overall structure or organization is standard. The repetitive, consistent use of type helps to give the publication its identity; it also serves as an easily recognizable guidance system to help readers find features and topics of particular interest. When newspapers, magazines, and other periodicals are redesigned, the readership always takes notice. Some complain, some cheer, but the change is felt.

Newsletters are in many respects like scaled-down versions of newspapers or magazines. Many of the design issues are similar, but since newsletters are usually not sold on newsstands, designing the front page in order to sell the publication is not a consideration. In the newsletter on the facing page, all three Stone subfamilies are used, but the appearance is still coherent.

A newspaper – the one shown on pages 38 and 39, for instance – is a landscape. The full-size broadsheet opened and held up before the face occupies almost the entire range of our vision. We therefore see many features surrounding us – monumental headlines, great pools of photographs, quiet captions, the demure index to the front section.

The use of bold weights for headlines has become a feature in the landscape of American newspapers that we have come to expect. Quieter presentations such as that of the *Wall Street Journal* seem to come from another era. The bolder and larger a headline is, the more it proclaims, "This is news! Read me!" If we equate the weight of typefaces with the loudness of the spoken voice, then we would have to conclude that a good deal of typographic shouting began in the nineteenth century and is still with us.

Design Notes: The newsletter is laid out within a grid, but this doesn't mean the layout has to look rigidly molded by the grid. Although the grid itself is highly structured, its use can be varied and lively. Breaking the grid may actually be part of the grid system.

Note the sparing use of rules (lines). Rules should be used to clarify structure. Well-organized typography reveals its structure without the aid of rules. This is one of the principle strengths of asymmetric, flush-left typography. The straight, flush-left axis can be aligned with other axes and edges to define relationships and otherwise provide a clean-looking publication.

In a newspaper, the issues are virtually the same as in a newsletter. But there's less opportunity for white space, so a boring layout is avoided by carefully balancing and punctuating with photos, headlines, and so on.

dateline:EARTH2000

The quarterly newsletter of the Artemis Society Legal Action Corps – Spring 1990

San Francisco Schoolchildren Support Endangered Butterfly Suit

The children expressed great concern for the butterflies, and since part of our educational philosophy is to create good citizens, I encouraged the students to express their opinions.

The endangered Simpson's butterfly is finding support from an unlikely source; sixth- and seventh-graders in San Francisco have written to the San Francisco District Court where the Artemis Society Legal Action Corps is suing to stop California grape growers from using ADL, a fertilizer which adversely affects the grape flowers' nectar, the adult butterfly's only diet. The case has generated great publicity in California and inspired the children's letters. Barbara Kuhr, presiding judge in the case, promised to consider the letters as she would any supporting brief, but added, "Since the letters do not discuss pertinent points of law, I doubt they will have any weight."

The California Grape Growers Association's lawyer Ron Stanton denounced the letter-writing. "These letters are a cheap move by the environmentalists –

using children to bolster their case. I can certainly have farmers' children write to the court saying they would like their dads' livelihoods preserved so they can put food on the family table."

Vivian Craige, a teacher whose sixth-grade class wrote to Judge Kuhr, denied being influenced by environmental groups. "We were discussing the case in our current affairs class, and the children expressed great concern for the butterflies, and since part of our educational philosophy is to create good citizens, I encouraged the students to express their opinions by writing to the judge. I did not imagine we would get publicity like this." Tom Soma, a Mission District current affairs teacher whose pupils also wrote, expressed his surprise "at how strongly the children felt for the insects. *continues on page 2*

Judge Strikes Compromise in Matheson Ranch Controversy

Judge Jan Uretsky's decision in the year-long Matheson Ranch suit, which pitted a dozen environmental groups including ASLAC against the National Park Service, struck a balanced compromise, permitting some restricted public access to the Ranch but keeping endangered species' needs in the forefront.

The decision allows the National Park Service to open the Matheson Ranch, deeded to the Service by former-oilman Randolph Matheson, to the public, but limits the visits to 500 people a year. The decision outlines that 10 percent of the visitors be scientists selected by a peer review on the basis of their research proposals. The remaining visitors will be members of the general public selected by application on a first-come, first-serve

basis. Judge Uretsky also required the National Park Service to "undertake every reasonable effort to maintain the Ranch's precious threatened species," including an instructional program to sensitize visitors to the danger their presence poses.

ASLAC along with other groups undertook the suit to prevent the National Park Service from opening the Ranch to thousands of visitors a year, a fate which would certainly have doomed the endangered flora which Randolph Matheson sought to protect. *Ceolena mathesonii*, a flowering cactus, and *Zyzia sara*, a shrub, "are two of the more than 15 plant species which are believed to be extinct outside of the 1,000-acre New Mexico ranch. By *continues on page 7*

St. Martin fishermen provide a model of sustainable yield. Page 2

The Hanover Voice

New England's Weekly Newspaper of Political Opinion and Art Criticism – Vox Clamantis in Deserto – Eighty Cents

Monday, 15 November 1996
Volume 23 – Number 926
P.O. Box 9, Hanover, New Hampshire 03755
© 1996 The Hanover Voice

Perhaps A New Aesthetic for the Presidency

Anthony McKenzie

The same old politics, but at least things would look nice

These days with yet another budget crisis, it is clear the government has difficulty accomplishing anything. Obviously having actors, peanut farmers and oilmen run our government has not been terribly effective. We need a new professional discipline to reorganize and invigorate the administration of our national affairs, a group accustomed to dealing with difficult clients. I propose graphic designers.

Graphic designers see it as their mission in life to organize others' written and visual materials. They notice and comment on poor displays of information wherever they see them. Walking down a city street with a graphic designer one will hear, 'Look at that sign. I can't bear that letter spacing!' Frequently when looking at a restaurant menu a designer's first comment will not be about the food, but the structure and layout of the menu. Since they have such analytical minds, let us set them to work on the federal bureaucracy.

Imagine what they could do with the Pentagon or HUD. With their love of white space, designers would eliminate all the unnecessary positions. Each position would have to be justified in a rational scheme. No more featherbedding. No longer would three people have overlapping duties. And, we would have understandable organizational charts.

A second, equally important credential makes designers perfect for the job: they are accustomed to dealing with difficult clients. Designers would have just the right touch in negotiating with Congress to obtain from the legislature the approvals necessary for a good federal de-

Heaven Can Wait

Groton debates Quantek's new satellite launching facility
Debate in Print

Sharka Hyland
Groton Citizens Action Committee

The Sensitive Information Act (SIA) of 1993 was the worse thing to happen to the public's control of its own fate. The construction, activation, and subsequent leak of critical orbital trajectory information at the Gillespie, Nebraska, Extraplanetary Mining Control Station (EMCS) was only the beginning. The three-month-old Groton Satellite Launch and Control Station (SLCS) not only threatens further leaks through corruption and incompetence, but also increased involvement of the United States in the Sino-Balkan standoff.

The unassailable argument against the

Tara Devereux
Mayor of Groton

The outrage of ultraconservative groups at the installation and operation of the Groton Satellite Launch and Control Station (SLCS) exhibits both their extreme ignorance of this government's civic responsibilities and their misunderstanding and mistrust of the Moore administration's motivations for sponsoring and implementing the Sensitive Information Act (SIA) in 1993.

Moore inherited a desperate situation when he ascended to the presidency after Richard Albin's assassination. The space shuttle program had just suffered its second great disaster caused by internal

Terry Dobson / courtesy Norton Gallery

Bez Ocko's photography exhibition at the Norton Gallery in Portland has riled at least one senior citizens' group and threatens to become the spotlight of another First Amendment feud. Page 7.

The Media Is the Mess

Presidential hopefuls perish or prosper by TV and the papers
Carol Lee Kaito

The press coverage of this year's election has been a disgrace. Never in recent history has the public been so ill-served by the fourth estate. Examples of the shoddy media performance abound. Here are three cases in point.

A Double Standard

The press corps has a double standard. Perhaps no better example exists than the treatment of Sloan Wilson's selection as the Republican vice-presidential nominee. When Wilson returned to his home-town of Little Rock, Arkansas, he broke down and wept, overcome by the emotion of returning to the scene of early political triumphs.

Four years ago when Kyle Cooper cried while defending his wife against the slanderous attacks of John DiRe's Manchester Union-Leader and Allen Moore's dirty tricksters, the press tagged him as weak and unstable. In short order Cooper's presidential campaign was in shambles, as much the victim of the press as of anything else. But, the press corps likes Sloan Wilson. His keen wit has made him popular among political reporters. His weeping was read as a touching sign that even though he was one of Moore's diehard defenders, the Arkansan was human.

Photogenic Media Favorites

The press creates political 'stars' who frequently do not deserve the respect and attention which the media showers on them. Perhaps because the Republican party is so totally devoid of political talent, Charles Altschul, Matthew Gaynor's top political technician, emerged as the dominant personality of the convention in Kansas City. The press painted Altschul as a political magician who emerged from the GOP conclave with increased stature and respect.

ble President. Altschul allowed the Burns forces to put his candidate on the defensive which slowed Gaynor's early momentum and probably lost him a needed victory in New Hampshire.

Gaynor's strongest suit was his outstanding ability as a campaigner in an era which relies so heavily on television and radio for information. Altschul neglected time and again during the primary campaign to exploit this Gaynor strength. Altschul refused to make a serious effort in the Pennsylvania, Ohio, and New Jersey primaries where Gaynor could have struck fatal blows to the staggering Burns

Never in recent history has the public been so ill-served by the fourth estate.

campaign. Instead the President was able to pick up those large blocks of delegates with virtually no opposition.

The choice of 'liberal' Sen. Nathaniel Connacher as Gaynor's putative running mate was Altschul's final and fatal mistake. Connacher probably cost Gaynor the support of the uncommitted Mississippi delegation and with it any chance of emerging as the GOP nominee.

Dwelling on Superficial Issues

Finally, the press has repeatedly shied away from examining the substance of the campaign, preferring to dwell on the personalities and media events which present good 'photo opportunities.'

At the Democratic convention viewers interested in issues were treated to a show which might have been titled, 'Jessica Habiland Goes to the Zoo.' At Kansas City the television networks presented "The

ideas would give designers a much better shot with Congress than actors who are used to following whatever directions their directors give them or oilmen who by nature always try to get the upper
Continued on page 7

that Symbiont ties have long existed between President Moore and Quantek CEO Scott Hight. Quantek received massive federal funding during the 1990 scramble to perfect low density guidance systems
Continued on page 6

He refused to unleash Matthew Gaynor until consecutive losses in New Hampshire, Florida, and Illinois had practically driven the conservative challenger from the race. By refusing to attack a vulnera-

istration, and the Pentagon was crippled in its sudden poverty. CIA Director Mary Cochran averred that 'so great was the confusion that Japanese espionage efforts
Continued on page 6

The lack of attention to matters of substance was particularly striking during Tom Habiland's primary campaign last spring. As James Waldron has noted in a
Continued on page 10

An abandoned sanitation truck and what should be its cargo lying beside Route 34 near Deerfield, Massachusetts. Residents of the town say the eyesore has been there since 1989.

Adrian Levin / The Hanover Voice

The Media's a Mess, But So Are We

Why do environmental problems still plague us when the legislators have done all they can?

Audrey Krauss

The Clean Air Act and the Clean Water Act have been revamped and are being enforced as they have never been in the past. Recycling centers are now as common as parking meters in midtown Manhattan. The virtues and motivations of all these efforts have been extolled by various news media and activist groups. Why, then, do we still have garbage and pollution everywhere? The answer can be found, if you are the typical American, by looking in the mirror.

Broad but Diluted Support

It would seem that the success of the environmental movement was carried through on the backs of a relatively small corps of energetic and committed believers and doers who led their lives and voted according to their one compulsion, much as the anti-abortion movement gained ground in Washington and state capitals under the command of zealous activists in the early 90s. Of course, environmentalism is not nearly the irreconcil-

able debate that abortion is; nevertheless, the battle was won by and for the committed few. The rest stood by giving their nods of assent, buying 'green' at the supermarkets, sorting out bottles and newspapers from their refuse, but really, for the most part, not participating in a truly positive manner.

A recent survey of workers that ride the MetroNorth commuter railroad to and from their businesses revealed that only 10 percent of them had switched to public transit from private vehicles within the last two years. Of those that had changed, only 15 percent of them cited environmental concern as the primary motivation for their change in habit. The remainder cited economic and convenience reasons primarily, noting the ecological benefits as an incidental effect.

Lack of Holistic Perspective

Recent studies show that less than 1 percent of businesses have actually decreased their consumption of office-grade

paper even though 62 percent of them participate in a recycling program for that material. In fact, statistics indicate that since the advent of waste-paper recycling, consumption noticeably increased in these businesses. The conclusion of this data – supported by direct interviews – is that recycling justifies additional consumption, since the paper's potential for becoming landfill material is removed.

Environmentalism demands a holistic perspective, and that is the one thing Americans tend to lack. Granted, it is sometimes difficult to assess the total environmental impact of a given product or process, but the irrefutable truth is that the less one uses, the less one refuses.
Continued on page 4

After Lin: 'Who and What?'

The absence of a loyal successor to Lin Pin may imperil his own success in the long run

Catherine S. Rediehs

The Chinese revolution of our times is a mixture of traditional and nontraditional elements, and this is true on both sides of the Taiwan strait. But Lin Pin's recent death now raises in acute form for Communist China some questions that Lu Xiaoma's death did not, namely who will succeed him in supreme control and what, if any, shifts in basic policy may ensue.

On Taiwan, Lu's death almost automatically resulted in the succession to power in government and Party of his son Lu Chingmei, whose policies are those of his late father. By contrast, Lin Pin never solved the problem of succession or policy continuity. Several times in the past he has designated successors-to-be, only to turn savagely against them and eliminate them. Both Chen Tzewu and Li Hanfeng were accused of plotting against him, and they were both opposed to his most basic revolutionary methodology, that of the 'continuing revolution' by struggle, force, and violence. The latest designated suc-

cessor to the major power in Communist China, Wang Min, supposedly a 'moderate' hand-picked by Yu Kiing, survived in power only very briefly after Yu's death.

Origins of the Problem

All this has come about because unlike his imperial predecessors in 'Peking of old, Lin Pin, although he married more than once, never had recourse to that socialistic collective, the royal harem. This institution had been employed in the past to guarantee even the heir apparent to the throne his own male successor in direct line, by the time he himself was only, say, fifteen years of age. But Lin left no male heir potentially capable of succeeding him. His closest relative is his wife, Fu Ching. But her succession to supreme power would not be a good solution in Communist China, not only because she is generally rejected on her own account, but because it does not accord with all-important Chinese tradition which is generally against female succes-

sion. So after Wang Min's fall, Hu Weide was named in his place. Just what and who Hu Weide was, was a puzzle to many of the 'experts' originally. But now a few things seems clear. Hu was undoubtedly the candidate, albeit a compromise one, of Fu Ching and her Maoist 'palace clique,' and should thus be in the orthodox Linist revolutionary tradition of struggle, force, and violence. He heads the militia, hundreds of millions of agricultural and industrial workers in lightly armed part-time military bodies, spread all over the country. This could conceivably give him the power to counter the full-time military who by and large dislike both Chiang Ching and Linist 'continuing revolution,' preferring instead orderly industrial growth for military sufficiency. Hu also heads the powerful secret police agencies.

If he can quickly put together these sources of political power, Hu might well come up a winner. But this is not to say
Continued on page 3

Who pays to repair the Battell Chapel in New Haven, Connecticut? Taxpayers? Page 2.

Lorraine Ferguson / The Hanover Voice

Inside...

Common Stock

Major Customer

Lease Commitments

Supplementary Statements of Income Information

The Company has authorized 100,000,000 shares of Common Stock. On 6 July 1988, the Company effected a two-for-one stock split. All references to common shares and per share amounts in the accompanying consolidated financial statements have been retroactively adjusted to reflect this split.

Under the terms of the Company's stock purchase plan, employees could elect to purchase common shares issued to them by the Company, at the fair market value of the shares on the issue date, through an 8% note payable to the Company. Shares issued under this plan vest over five years. In the event of employment termination, unvested shares may be repurchased by the Company at the original purchase price. At 30 November 1988 there were 579,154 unvested shares. The Company does not contemplate issuing any further shares under this plan.

At 30 November 1988, the Company had reserved 1,400,000 shares of Common Stock for issuance under its stock option plan. This plan provides for the granting of stock options to employees (including officers and directors) at the fair market value of the Company's common stock at the grant date. Options generally vest over three years; 25% of the granted options at the end of each of the first two years and 50% at the end of the third year. On 18 June 1988, the Company accelerated to that date the exercisability of 498,320 outstanding options. Unvested shares remain subject to certain company repurchase rights. All options have a five year term.

The table to the right summarizes option activity: ➤

One major customer accounted for 42%, 37% and 34% of the Company's total revenue for 1988, 1987 and 1986, respectively. Receivables from this customer aggregated approximately $6,000,000 at 30 November 1988. At 30 November 1988, this customer was also a major shareholder, owning approximately 13% of the Company's common shares.

The following items are included in costs and expenses in the accompanying consolidated statements of income:

The Company occupies its facilities under a lease agreement that expires on 29 January 1991. Minimum future rental payments for 1989, 1990 and 1991 are $557,000, $597,000 and $28,000, respectively.

Rent expense for 1988, 1987 and 1986 was $480,000, $206,000 and $83,000, respectively.

Supplementary Income Information	1988	1987	1986
maintenance and repairs	$ 330,000	144,000	99,000
depreciation	1,072,000	669,000	421,000
amortization of production costs	338,000	—	—
royalties	1,872,000	364,000	—
advertising	460,000	275,000	64,000

Stock Option Activity	shares available for grant	options outstanding [shares]	options outstanding [avg price]
shares reserved at 1 Dec 1984	863,420	—	—
options granted	(418,600)	418,600	$.60
balances at 30 Nov 1985	444,820	418,600	.60
increase in share reserves	536,580	—	—
options granted	(287,720)	287,720	.60 – 9.88
options exercised	—	(463,820)	.60 – 1.00
options cancelled	8,600	(8,600)	.60
balances at 30 Nov 1986	702,280	233,900	$.60 – 9.88
36,075 shares exercisable			

23

Annual Report: In annual reports, corporations strive to impress their stockholders with a sense of their managerial competence and reliable performance. Most annual reports are therefore distinguished by conservative, clean design. Sans serif typefaces carry a feeling of austerity, sparseness, lack of frills, straight-forwardness, and clarity – all virtues that carry weight in the business world.

An annual report contains a lot of text to be read continuously – a situation that traditionally would call for the easy legibility of a serif typeface. But as the Stone Sans was designed to be related through its inner structure to early serif text typefaces, it is legible enough to work well in long passages of text.

Design Notes: In tables, statistical graphics and typography overlap. The design follows from the very logical structure of the tabular material. Careful alignments in both dimensions clarify which headings belong to which rows and columns and generally impose a welcome degree of organization. In the page below, the closing parentheses seem to violate the alignment – but it is more important to align the digits of figures. Also, the placement of the comma following December 31 in the right margin gives a more solid flush-right edge to the table. I used the same column spacing in both tables so that they would align vertically with each other.

QUANTITIES OF POTABLE WATER RESERVES	Noncarbonated Water thousands of liters			Carbonated Water millions of liters		
	1988	1987	1986	1988	1987	1986
Balance – beginning of year	915,363	951,211	848,931	5,846	7,004	7,111
Revisions to previous estimates	(18,214)	3,239	3,862	186	(837)	(404)
	897,149	954,450	852,793	6,032	6,167	6,707
New well discoveries and extensions	41,977	20,090	59,573	1,693	78	693
Purchases of reserves [1]	12,800	9,484	91,378	20	57	57
Production	(73,862)	(71,500)	(50,700)	(502)	(359)	(413)
Sales of reserves	(486)	(2,162)	(931)	(25)	(98)	(13)
Balance – end of year	877,578	910,362	952,113	7,218	5,845	7,031
Proved developed reserves at end of year	678,763	742,599	766,814	4,954	3,455	4,551

1. Includes, in 1988, reserves acquired in the merger with Autumn Springs.

CAPITALIZED COSTS RELATING TO PRODUCTION ACTIVITIES	thousands of dollars December 31,		
	1988	1987	1986
Unproved wells	$ 16,255	$ 12,297	$ 26,722
Proved wells	883,953	817,231	685,399
	900,208	829,528	712,121
Accumulated depreciation, depletion, amortization and valuation allowances	(254,481)	(200,479)	(153,396)
Net capitalized costs	$ 645,727	$ 629,049	$ 558,725

Signage Systems and Interactive Displays

In signage systems and public computer displays, the functional aspect of typography is uppermost. In both cases, the typography serves a navigational purpose. Legibility, clarity, and simplicity are at a premium; the text tends to be limited to only a few words. Sometimes it is vital that we get the message. For instance, the proper reading of a highway sign can mean the difference between going to Yosemite Valley and going to Sacramento, or even between life and death.

Signs that give directions and information are only one specialized kind of signage. Their primary function is to communicate specific information clearly and quickly. The typographic style, while secondary, is still important because of its role in helping to create the visual atmosphere of a place.

Style is more important in the larger category of commercial signage – the vast collection of typographic messages that surround us in industrial, urban society and transform our visual environment. Their impact is especially noticeable in their absence, for instance in old sections of cities where commercial signs are forbidden in order to preserve the historical flavor, or in the countryside away from roads. If in designing a sign we consider its setting as well as its purpose, we can avoid increasing the visual pollution we live with.

In interactive display screens, and on computer screens in general, we see a typeface at its most humble and crude. Because computer screens are low-resolution devices, the dots that make up the images are large and therefore limited in their ability to portray the fine details of letterforms. On such a display, for instance,

a 10-point character for a text typeface will have stems that are only one dot thick. Unless the letterforms are carefully rendered, screens can even distort the appearance of the type, making it harder for the user to grasp the message.

The computer screen was always at the edge of my consciousness as I was developing the Stone letterforms. After all, they were largely drawn on the screen. I wanted them to have high legibility on low-resolution devices and so was careful to avoid features that can cause problems, such as lines that are not quite horizontal or vertical.

Interactive displays are most effective when they rely on large, simple images and avoid clutter. Type sizes need to be kept fairly large as well; otherwise the user will have to strain to read the text. In the displays on the facing page, the divisions into black and white fields and the use of reversed lettering (white on black) as a means of distinguishing the kinds of information are simple and effective devices.

Design Notes: Since the displays are fleeting over time, it is very important to be typographically organized, and the information itself must be well organized. Something can't be well designed if its content hasn't been well written and organized in the first place.

Coventry Zoological Gardens
Information

This interactive computer display presents information about the Zoo's exhibits and special events. In order to make selections, just touch the appropriate "button" on the screen.

► *Touch anywhere on the screen now to see the* INDEX.

Zoo Highlights: **Bengal Tiger** Touch screen to go on.

San Simeon Aquarium

→	$	●	→
Entrance	Adults $ 6.00 Children < 12 1.50 Students 3.00 Senior Citizens 3.00	No flash photography, please!	**Exit**

mammals

↑ whale tanks
→ seal cove
→ otter habitat

Killer Whale

Orca orca

The largest members of the dolphin family, killer whales inhabit all waters of the world. In packs they hunt fish, squid, and occasionally seals, sea lions, penguins, porpoises, and dolphins. There is no record of a human death from a killer whale.

↑ ↗

Aquarium
Parking

→

EMERGENCY
EXIT

●

Thank you!
Please come &
visit us again.

In this signage system for an aquarium, the role of the Informal typefaces is interesting to me. Instructions and admonitions – for example, "No Flash Photography, Please!" – have been set in the Informal. The visual "speech" of the Informal lends a somewhat friendlier tone. More neutral information, such as directions, is given in Sans Semibold. And the emergency-exit sign speaks to us in the more formal capitals that are appropriate to the message.

Design Notes: In a signage system, each sign must be clearly understandable on its own and must also suggest the total system. Aspects to consider: how the size, weight, color, and letterspacing of the type affect readability at distances and in various light conditions; what the signs say (their language) and where they are put.

The semibold characters are the best weight to be recognized at great distances in both positive and reverse form – they strike a good balance between sturdy strokes and open bowls (the inner spaces of the a, e, o, and so on).

Corporate Identity

The idea of the corporate identity has been with us for a long time. Family crests, flags, cattle brands, the marks that printers, paper makers, goldsmiths, and other craftspeople of medieval Europe stamped, burned, or otherwise impressed into their work – these are all intended to identify the maker in an encapsulated, distilled visual form. The phrase *making your mark* is still with us, and says it well.

Modern business, government, and educational institutions have continued this tradition by having designers create identity systems for them. An identity cannot be created merely by designing a mark. The mark must also be used in a consistent, coherent way.

In today's highly commercial world, we use logos to mark an enormous number of things – buildings, packages, T-shirts, pens, matchbooks, business cards, letterheads, envelopes, forms of all kinds, cars and trucks, and so on. Therefore the marks used for this purpose work best if they are simple enough to be reproduced in a variety of media and still distinctive enough to serve as effective conveyors of some messages about their organizations.

Many corporate identities depend on letterforms. The forms of the letters speak to us on a purely visual level that is quite separate from the letters' verbal or analytic content. We respond to the shapes of the letters even though they are not necessarily shapes that we recognize from nature. I have been surprised at how strong the emotional response is among people who have just begun to notice letterforms consciously. Very soon after starting to use typefaces, people seem to develop strong likes and dislikes for certain styles. Of course, letter shapes can evoke an emotional response even when we are not consciously aware of their power.

Design Notes: A corporate identity is more than a logo. The components of a system include first the mark, then such secondary graphic elements as rules and bars and such typographic stylistic elements as typeface, leading, and size. Consistent use of color is also vital. All these aspects together create an attitude, a visual language. Consistency builds an identity.

In the puppet identity system, the design of the blank letterhead (facing page) takes into account the position of the "typewritten" body. The so-called typing format is an integral part of the letterhead. Computer templates in word processing programs make it easier to position the text. Otherwise a small dot is printed to indicate the place to start typing the letter. Altogether there should be a clean appearance.

Allen Moore
Master Puppet Maker

Jacqueline McGuire
Director of Public Relations
Barash Hertko & Schunick, Inc.
345 East 15th Street
New York, New York 10003

14 November 1987

Dear Ms. McGuire, Thank you for your interest in
Puppets for the design and creation of large-scale a
tell you that we do not normally produce puppets (
costumes?) that are operated by a person contained
very charmed by the nature of your upcoming fund
handicapped that we have all agreed that this would be a welcome
exception to our normal *modus operandi*. Yet even though these puppet-
costumes are something we don't do normally, we assure you they will live
up to our reputation for quality and originality.

The estimates that you requested will take us a few days longer because of
the scope of the project. We are currently looking for and pricing fabrics, as
well as the aluminum framework that will be necessary in some of the
animals, e.g. the elephant and giraffe. I already have some ideas for
mechanisms that will allow the puppet-costumes to move in very comical
ways.

Copies of some of my rough sketches are enclosed. Please let me know if I
am heading in a direction which is agreeable to you. It is really a pleasure
to work on this.

Yours,

[signature]

Allen Moore
Master Puppet Maker

Rudyard Puppets, Inc.
120 MacDougal Street
New York, New York 10012
212.765.4321

Rudyard Puppets, Inc.
120 MacDougal Street
New York, New York 10012
212.765.4321

		date						
		origination						
		destination						
		purpose of trip						
transportation	auto	mileage						
		rate x miles						
		rental						
		parking						
		tolls						
	other	air fare						
		rail fare						
		car / bus fare						
		limousine / taxi fare						
		tips						
lodging		room charges						
		tips						
miscellaneous		postage						
		telephone / fax / telex						
		laundry						
		other (attach statement)						
		subtotal						
meals and entertainment		meals on travel status						
		meals with business discussion*						
		other business entertainment*						
		subtotal						
		meals without business discussion						
		trip totals						

r

* explain on reverse side

less cash ad

balance due

Travel Expense Report

name
department
period beginning _____ ending (inclusive) _____ page___ o

Design Notes: A form depends on organization and grouping of information. It is almost engineered. Ideally, it is self-explanatory and considers both the person filling in the form and the person reading the form to find specific information. The rules are thin so that they won't be obtrusive once the form is completed.

When everybody is shouting, as in a phone book, sometimes it's best to be quiet. Typically a phone book is very busy, and clean, elegant typography stands out. So does an interesting typeface. Compare the puppet ad with the small Franken Pump ad, in which organization is lacking and hierarchies are not clearly distinguished.

You are cordially invited to attend the

Sixth Annual Benefit Show

featuring the Rudyard Puppets

and the Lederhosen Puppet Troup of Munich, West Germany

Sunday, September 23d, at three o'clock in the afternoon

The Little Red Theatre, 39 Grosvenor Street

All proceeds will be donated to Habitat for Humanity

A logo should communicate important information about the organization it stands for, such as its connections with cultural traditions and similar institutions and its own view of its personality and role in the community. A logo's ability to communicate on this level will determine its success or failure as an identifying mark.

Design Notes: Logos are about shape, suggestion, positive and negative space (the image itself as opposed to the space around it), clarity, memorability, propriety, scalability (enlarging and reducing), among other things. A logo can be a symbol that is abstract, representational, or based on letters or initials that do not reveal the company's full name; or it can be a logotype consisting of the company name set in a particular way. If a symbol is used, as in The Astor Place Playhouse, the company name needs to be set in a certain typeface and in a certain size and place relative to the symbol. Using Stone for both the symbol and the identifier line gives a special unity.

The Astor Place Playhouse

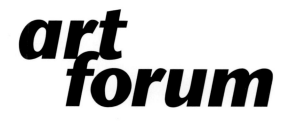

M&N

Han Feng
New York · Paris · Tokyo

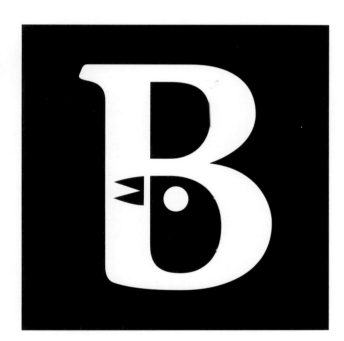

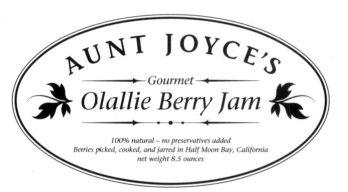

AUNT JOYCE'S
— Gourmet —
Olallie Berry Jam
· · ·

100% natural – no preservatives added
Berries picked, cooked, and jarred in Half Moon Bay, California
net weight 8.5 ounces

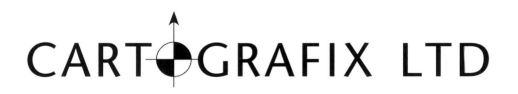

CART🧭GRAFIX LTD

Promotional Materials

Until recently those interested in type and typography have made a very clear distinction between advertising typography and book typography. The practitioners of one discipline regarded the practitioners of the other with suspicion and disdain. Now the boundary between these two groups has become fuzzy, as have many other divisions in the typographic world. Individual designers are called on to produce many different kinds of documents, using both text and display typography. This has led to a great deal of "crossdressing" in the world of typographic design. For example, typefaces that were intended to be used for books appear on billboards, and typefaces designed for display advertisements are used for setting books.

At times designers of promotional materials face the initial problem of simply catching the attention of potential customers in a marketplace that has changed little since the bustle and clamor of the medieval fair. Shouting loudly is a strategy that is still employed in the contemporary versions of such places all over the world, but it is not the only strategy. Sometimes a quiet and orderly presentation will attract attention more readily than shouts. In any case, the strategy must be geared to the prospective customer.

Although large and bold type may be reminiscent of shouting in the marketplace, it is also a logical choice to assure that the message is legible. To be read at a distance, large type must be bold. We can test legibility by printing a single word in each weight of a particular typeface at a variety of sizes and observing the results at various distances. Such experimentation is a necessary part of the graphic design process.

When a printed piece is used to sell something – whether meals at a restaurant or products in a store – how it looks can influence our willingness to buy and even our initial impression of the product or service. I have been correctly accused of buying bottles of wine because of the label.

In a menu, the goal is to describe the restaurant's dishes, preferably in a manner that will make patrons ravenously hungry. The best way to do this is in a list, which has always been one of my favorite forms of writing. In the sample menu on the facing page, Sans Bold has been used to highlight the names of the dishes, and the brief, mouth-watering descriptions are easily distinguished from the names by their placement and the use of Sans Italic. Although three different type styles are used here (the headings are in Serif Medium), the menu is visually appealing, "easy to digest," and carefully prepared and conceptualized – just what we might hope of the food as well.

Design Notes: Emphasize names of entrées; de-emphasize prices (by running them into the descriptions). It's possible to make the Stone faces look more different from one another by varying style: all caps, letterspacing, and so on. To create a typographic theme, make a big deal of a small thing. If you're going to indent, really indent!

SALADS

Leslie's Caesar Salad

a colorful toss of vegetables with optional anchovies or chicken 5.50

Fisherman's Salad

shrimp, squid, clams, and mussels with a white wine and dijon dressing 8.50

Oriental Bean Sprout and Chicken Salad

fresh greens and chicken cubes with a sesame dressing 5.50

ENTRÉES

Breast of Chicken Cockaigne

an Alsatian recipe served with a special gravy and French bread 9.00

Rangoon Curried Chicken

a Burmese recipe spiced as you like it and served with yellow rice 9.00

English Pheasant in Game Sauce

something to dispel all the rumors about British food 14.50

Honey Almond Lamb

our sweet Moroccan recipe served with couscous 12.50

New York Sirloin Steak

a 12-ounce steak with copious fries and a crock of fresh steamed veggies 12.50

Pan-Fried Fish with Black Bean Sauce

Szechuan style, served with transparent rice noodles 15.00

Piroshki Vosatka

Polish meat turnovers with brown sauce and boiled potatoes 11.25

Shrimp and Vegetable Tempura

bite-sized pieces dipped in a terrific batter and deep-fried 17.75

Tortellini Alfredo

tortellini and early peas bathed in a thick cream sauce with tarragon 8.50

Yale

Summer Program in Graphic Design

Brissago, Switzerland

The program centers on theoretical and practical exercises dealing with the essential elements of Graphic Design. Included are color, typography, landscape drawing and abstraction, visual semantics, three-dimensional design, and poster design. All classes are conducted in English and take place in Brissago, a small town on the shore of Lake Maggiore in the Swiss canton of Ticino.

6.11–7.18.1988

Yale

Program

The program is an official academic session of Yale University and six credits are granted for work which is satisfactorily completed. The program is open to all qualified graduate and upper-level undergraduate students currently enrolled in an accredited university or art institute. Also eligible are designers and educators who have already received their terminal degrees or have the equivalent in professional experience.

Location

Located in the Swiss Canton of Ticino, Brissago dates back to Roman times and was officially founded in the 14th century. The village lies just north of the Italian border at the foot of Monte Gridone and on the edge of Lake Maggiore, a lake which extends from Locarno forty-one miles south into Italy. This area is one of the few in Europe that enjoy a semi-tropical climate.

Tuition

Tuition, which covers room, board, study trip expenses, and course materials, was $3,100 in 1987. Students are responsible for their own transportation to and from Brissago. Further information, including the admission application form, is available through the Office of Academic Affairs, Yale University School of Art, 180 York Street, P.O. Box 1605A Yale Station, New Haven, Connecticut 06520.

WHAT IS GRAND STRATEGY?

"The British Problem
in the First World War"
Sir Michael Howard
Sterling Professor of History
Oxford University

7:30 pm
Monday, September 21
Williams Auditorium

Summer Program: In this flyer, the flavor of the graphic design is a significant part of the message. This effect is made more complex because the flyer is addressed to an audience that is predisposed to notice the design as part of the message. For most audiences, we must assume a much lower level of conscious awareness of the meanings associated with the purely visual aspect of the design.

Design Notes: Give identity and impact to a single piece by carrying a simple idea throughout, for example angled type, lots of leading, small type juxtaposed to big type, a motif (the Swiss cross).

Grand Strategy: On a university campus, lectures are given all the time, and they are advertised by posters ranging from hand-scribbled notices to well-designed printed pieces. The challenge is to design something that will stand out from the wallpaper-like clutter of announcements. This poster would probably succeed with its bold typographic treatment.

Design Notes: If you can't use photography or other art, and type isn't enough, add abstract elements but try to make them meaningful. In the Grand Strategy poster, for example, the triangles suggest backgammon or teeth – in any case, opposition or tension. Also note how the angled type is integrated with the triangles forming the borders.

The Sand Hill Road ad (page 56) is another example of integration. Headline, image, text come together, literally. Note especially the syntactical line breaks (by phrase) – easy to read and creates an interesting right rag.

The AutoCare ad (page 57) uses a motif, the circle. Even the dotted line is part of the motif, and so is the period in "776.3000." Note optical alignments: the x-height of "European AutoCare" aligns with the cap-height of "86 Liberty." When aligning, look for the most solid "lines." Since there are few capitals and ascenders in "European AutoCare," the x-height is more solid than the cap-height.

2500 Sand Hill Road

The interior design
of the eighth floor
of Twenty-Five Hundred Sand Hill
was commissioned
by Corniche & Halston Advertising,
and reflects their special taste and needs.
Entering through a corridor-like foyer,
the curved exterior wall
of the main conference area
beckons the eye
to a 40-foot, south-facing,
floor-to-ceiling bay window
and a magnificent 180-degree view
of the valley below.
The space on either side
is a system of angled walls,
colors, textures and natural light
that divides the space
without being dull about it.
Rather, these elements create
varied spacial experiences
while providing diverse functionality,
much like the grid
of a bustling miniature city.

repairs
service
body work
paint

Alfa Romeo
Audi
BMW
Citroen
Mercedes
Peugeot
Porsche
Renault
Saab
Volkswagen
Volvo

Acura
Honda
Mazda
Mitsubishi
Subaru
Toyota

We've just learned a new language!

European AutoCare

85 Liberty St.
Winston Salem
776.3000

In the two posters on these pages the letterforms seem to have a life of their own. Min Wang, the designer, was a graphic design teacher in China before he came to the West to study. With the innate reverence for written characters that has endured for so long in China, he seems to look at Western typography with a somewhat detached but attentive eye, readily seeing the artistry of the forms as distinct from the letters' functional role.

Design Notes: Instead of using a completely free arrangement of the characters, Min imposed a loose grid – maybe to suggest that typography is not a totally unconstrained endeavor. In the Japan poster, note how the bullets stand outside of the copy – not disturbing the flush-left alignment of the text itself.

**Seattle
Cultural Festival
1992**

Saturday, 21 August 1992

The Seattle International Center for the Arts
400 Second Avenue South
Seattle, Washington 98104
206 / 622 4499

Since 1945, Japan's accomplishments in the arts have virtually equalled her economic ascension. Of course, these recent achievements are built upon centuries of rich tradition. This year's Seattle Cultural Festival presents the recent works of Japanese and Japanese-American creators in the visual arts, performing arts, architecture, industrial design, and cuisine, and it aims to distill the modern, the traditional, and the *Japanese* contributions to our global cultural environment. In sum, the Festival comprises:

- a main gallery space devoted to painting, photography, and sculpture, with gallery tours every hour on the hour
- exhibitions of architectural models, appliances, furniture, and graphic design
- performances and lectures in two auditoriums, and continuous screenings in smaller theaters
- authentic Japanese catering and cooking demonstrations

Tickets are $5.00 for adults and $2.50 for children under 13 years, and they may be purchased at the Festival or in advance at the SICA box office. School groups are welcome to arrange special rates by calling SICA's Academic Liaison, Alisa Barratta, at 622 4499, extension 207.

This event is made possible by a grant from the National Endowment for the Arts.

The following are highlights of the program. A complete program will be available at the Festival.

10:00 Japanese Calligraphy Demonstration
 Joseph Isuzu, Graphic Designer
 Pacific Gallery

11:00 Lecture: *From Origami to Airport Terminals: Modern Japanese Three-Dimensional Design*
 Dr. Steven Kagaro
 Director, Tokyo Institute of Art
 Durant Auditorium

12:00 Sushi Preparation
 Joyce Tanaka
 Chef, The Rising Sun Restaurant
 Mount Rainier Cafeteria

1:00 The Kobe Chamber Quintet
 Modern Compositions
 Durant Auditorium

2:00 Film: *Ran*
 Akira Kurosawa, Director
 Arnold J. Nordstrom Auditorium

3:30 Gallery Tour: *Past and Present in Modern Japanese Painting*
 with Dr. Hiroshi Shinya
 Emeritus Professor of Art History
 University of Washington
 meet in the West Gallery

5:00 Film: *The Seven Samurai*
 Akira Kurosawa, Director
 Arnold J. Nordstrom Auditorium

7:30 Dance concert:
 The Nagasaki Kabuki Troupe
 Durant Auditorium

Painters
Yoshio Hasegawa
Yutaka Hasegawa
Yusaka Kamekura
Elizabeth Maezawa
Michael Nagai
Karen Yamauchi
Tadanori Yokoo

Sculptors
Atsuo Aoyama
Sakae Kakigi

Photographers
Max Fujishima
Shozo Kakutani
Yo Takanaka

Graphic Designers
Shigeo Fukuda
Mitsuo Katsui
Jospeh Isuzu
Koichi Sato
Ikko Tanaka

Industrial Designers
Kiyoshi Awazu
Takenobu Igarashi
Tomoyuki Suzuki
Eri Tanaka

Architects
Fumihiko Enokido
Hiroyasu Itoh
John Miho

Filmmakers
Karen Klein
Akira Kurasawa
Mikio Sakai

Animators
Akihiko Morita
Yoshio Takanaka
Hiro Watanabe

Chefs
Susan Abarbanell
Kenji Fukuda
Joyce Tanaka
Masatoshi Toda

japan

Form and Spirit

Personal Uses

Only a few years ago the typewriter was the only technology available to most individuals who wanted to write or print something by mechanical means. At that time the category of "personal uses" would probably not have appeared in a book on type. The situation has changed radically since the introduction of the Apple LaserWriter and the Hewlett-Packard LaserJet printers. Documents that would once have been taken to a professional to design and produce – invitations, résumés, important correspondence, and so on – can now be done entirely at the office or at home. But whether we are working on personal communications or more formal, public documents, the issues of use, style, and meaning are equally important.

When we send a résumé to a prospective employer we must anticipate that our document will join a flood of paper from other hopefuls. How can we be sure that our résumé is noticed and not swept away? How can we set the right tone, so that the résumé both reflects our background and individuality and is appropriate for the audience? Because recipients of résumés rarely read more than a page or two, we must also be able to include in a small space enough detail to tell our story fully – or as much of our story as we choose to tell for the specific post or field.

To meet these needs we must make certain decisions about type style, size, spacing, and so on. Our type choices and design will probably vary radically depending on whether we are applying for a position in the arts or a job as an insurance underwriter, for instance. The résumé opposite has a very conservative, homogeneous look – the result of using serif type throughout the document in a consistent size, varied only by a restrained sprinkling of italics and boldface to highlight information. We learn from reading the résumé that Richard Philip Burton is – or soon will be – a doctor and that he is interested in pursuing a career in orthopedic surgery, a field requiring great precision, serious intent, and set procedures. The feeling of the résumé therefore seems quite appropriate.

Design Notes: A résumé is an information design problem. The guide words on the left are the key to this résumé. They don't need to be bold or italic because they are spatially isolated from the body of the document. Making them bold or italic would only add busyness, which would make for visual confusion.

How to make a distinguished-looking résumé: Don't center anything. Or else center everything.

Richard Philip Barton

present address
409 South Grover Street, Apt. 3, Saint Louis, Missouri 63112
314 / 472 9950
permanent address
2001 Hyland Street, San Francisco, California 94123
415 / 933 8760

personal
born 6 April 1960, Omaha, Nebraska
marital status: single
excellent health
fluent in English and Spanish

medical education
Cochran University School of Medicine
10455 Bandley Boulevard, Saint Louis, Missouri 63104
expected confirmation of M.D. degree, May 1988

honors
pharmacology, pathology of systems, psychiatry, physical diagnosis,
and genetics (near honors)

activities
Pathology Class Review Committee
Experimental Surgery: Canine Lab
Support Group for Medical Underclassmen
Preceptorship: Orthopaedics with Dr. John DiRe
intramural basketball, football, softball

undergraduate education
University of California, Berkeley
Berkeley, California
Bachelor of Arts in molecular biophysics & biochemistry 1983

honors
Honor Student winter quarter 1978
Honor Student spring quarter 1978

activities
Minority Pre-Med Health Sciences Group: Founder 1981
Student Learning Center: tutor in physics, chemistry, mathematics, Spanish
San Francisco Ambulance Service: volunteer 1977–78
Martinez Veterans Administration Hospital: Lecture Series volunteer 1979–82
Berkeley Free Clinic 1981–83

high school education
Martin Wilson High School
2386 37th Avenue, San Francisco, California 94124
diploma 1978

honors
California Grant Scholarship for 4 years of college

employment
hardwood floor contractor, independent 1984
Montgomery Burns Construction Company, carpenter 1981–83
Waldron National Bank, teller 1979–81

professional associations
American Medical Association 1985–present
AMSA 1984–present

memberships
San Francisco Olympic Club
outside interests
carpentry, sailing, alpine skiing, water skiing

specialty of interest
Orthopaedic Surgery
research
Surgical management of acute myocardial ischemia following
percutaneous transluminal coronary angioplasty
Under the supervision of Dr. Ruth Waldheimer

By responding affirmatively to this solicitation, you accept all of the terms and conditions of this Agreement. This invitation of Tammy Haimov's Law School Graduation Party (the "Event") is extended to the Bearer (or "Attendee" or "you") by Tammy Haimov (the Celebrant) only under the terms of this Agreement. If you do not agree with the terms and conditions of this Agreement, exceptions may be granted according to the Haimov Amnesty Act of 1990, a copy of which may be obtained upon request to the US Department of the Interior, Bureau of Bogs and Swamps.

I. Intent of Invitation. This document is for the sole and express purpose of causing the bearer to appear at the Haimov house in Pound Ridge, New York, (the "Site") with legitimacy and favorable disposition. This invitation is not transferable except to Supreme Court Justices and name-partners of law firms. (The full provisions of the Haimov Amnesty act shall be duly accorded to these individuals.) This invitation is in lieu of all other invitations for events occurring on 20 May 1990 sponsored by third parties, including but not limited to the Attendee's mother's birthday and the Attendee's own birthday, which, in consideration of the historical significance of the Event, must be postponed. Other than the provocation of bodily transportation to Pound Ridge, this invitation make no warranties, express or implied, regarding fitness for a particular purpose, including but not limited to origami, wrapping of smoking materials, or proof of friendship.

II. Attendee's Representations and Warranties to Celebrant. The Attendee represents and warrants that: (a) the relationship between the Attendee and the Celebrant prior to and resulting in the issuance of this invitation has been developed in good faith, with benign and mutual interest and reasonable advance notification of homicidal proclivities that may arise at the sight of celery sticks; (b) the activities of the Attendee shall not infringe upon or violate the rights of any third party or think about going to another Party including but not limited to the rights of dry habiliments and choice of cold cuts; (c) the Attendee has the full power to enter into and float in the water.

III. Celebrant's Representations and Warranties to Attendee. The Celebrant represents and warrants that: (a) the Attendee will have a good time; (b) the Attendee will be well fed; (c) the Attendee will have his or her turn in the row boat; (d) the Attendee will be provided with a floatable life vest for the purpose of water sports, though if the Attendee has invoked the Haimov Amnesty Act he or she is subject to choose among a set of life vests that includes one (1) vest filled with lead pellets; (e) there shall be no invocation of billable hourly rates.

IV. Indemnity. The Attendee indemnifies and holds the Celebrant harmless from and against any claim, loss, mosquitoes, piranhas, costs or expenses (including, without limitation, reasonable catering fees) of any kind and character suffered or incurred by the Celebrant by reason of association with the Attendee and the Attendee's unforeseen behavior at the Event.

V. Successors and Assignments. The Attendee agrees not to transfer, sell, sublease, assign, pledge or otherwise force upon a third party either for or against its will the invitation to the Event or the rights under this Agreement without the prior written consent of the Celebrant. If this invitation is assigned to a third party it shall have a cash value of not less than $1,000 (one thousand dollars), and the Celebrant is entitled to 50% of the net proceeds. Supreme Court Justices and name-partners of law firms are exempted from the provisions of this article.

VI. Termination. This invitation may be revoked, without cancelling this Agreement if the Attendee becomes uninvited at the Site, at any time for any reason, including but not limited to dislike of the Celebrant's mother's potato salad, recklessness with lawn darts, and discharge of nitrogenous liquids either by stealth or overtly into the Site's adjoining lake within 50 meters of shore. This invitation and the rights accorded herein effectively terminate at 11:59:59 post meridian Sunday 20 May 1990 and are non-renewable, frameable, scrapbookable and recyclable.

VII. Accuracy of Information. The time and location of the Event are subject to change without notice to the Attendee for any reason whatsoever, including but not limited to caprice and major department store sales. Traveling directions are correct as of 1 May 1990 and shall be correct on the day of the Event seismic occurrences and highway redevelopment notwithstanding. The Celebrant is expressly not liable for wrong turns and passed exits directly or indirectly arising from somnolence, exchange of strong language or engagement in improper activities in the anterior portion of the passenger compartment of the vehicle or in the posterior portion of the passenger compartment if the vehicle is in unattended motion.

Skip the fine print.
Just come to my graduation party.
Trust me.

Sunday, 20 May 1990, noon (or 27 May if it rains).
Bring a bathing suit for the lake, an appetite for the barbecue.

Directions to the house at Pound Ridge enclosed.
If you don't have a car, please let us know and we'll arrange a car pool.
RSVP 212 765 4321

Graduation Party: It's an invitation to a law school graduation party, and it's also a joke. The fact that, at first glance, it doesn't look like a joke makes the joke all the better. Imagine having to wade through all the fine print to get to the real message.

Wedding: An invitation is one of the most personal of printed pieces. The type used in this example, Serif Medium Italic, was based on calligraphic letterforms made with an edged pen. This part of the Stone Serif typeface is closely connected to my own lettering roots – italic was the first alphabet style I learned.

Design Notes: I hand-tuned the alignment of the three lines of large type in the law school party invitation in order to make the initial capitals look optically flush left. In most serif typefaces, the use of the fl ligature, as in "fine print," avoids the collision of the dot of the i and the overhanging top of the f. The fl ligature serves a similar purpose. Stone Informal is an appropriate type for the casual blackout party invitation, while Stone Serif Italic, with its distinct calligraphic derivation, provides a modern alternative to the scripts often used for formal social announcements.

Mr. and Mrs. James A. Bell

request the honor of your presence

at the marriage of their daughter

Cynthia Janelle

to

Stephen Arnold Appleton

on Saturday, the twenty-third of June

nineteen hundred and ninety

at one o'clock in the afternoon

The Daihozan Myosetsuji Temple

253–84 Beech Avenue

Flushing, Queens, New York

Isaac's Blackout Party!

Why sit at home in the dark when you
can live it up at my place?
A generator will keep the stereo and blender
going, but please bring candles.

8 o'clock until whenever *you* black out
Tomorrow, August 8th
57 Willow Pond Road, off Todt Hill Road

We're on – pitch black or shine!

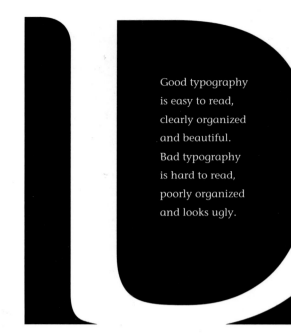

Good typography
is easy to read,
clearly organized
and beautiful.
Bad typography
is hard to read,
poorly organized
and looks ugly.

Typography as Art

Typography and type design are arts just as painting and photography are. Should we distinguish between applied art and fine art? Is applied art less creative, original, inspirational, important, because it is embodied in something useful? Does fine art have a function? Is its function simply to be itself, to speak to us in some emotional, spiritual, intellectual, or other fashion? Are useful objects that communicate to us in these same ways not also art? Can objects as common as letters be works of art?

I raise these questions to draw attention to the lack of legal protection for typeface design in the United States. While painters and photographers enjoy legal protection for their work, type designers do not. In the computer field, a computer programmer can obtain a copyright for new programs, while a designer who creates new type for the computer cannot.

The creative effort invested in new type designs is considerable. Although the new technology of personal computers and laser printers has made it easier than ever to make new and beautiful typefaces, it is also making it easier than ever to copy existing designs. Legal protection for typefaces would be an important step in building a firm foundation for the continued growth of the typographic arts into the twenty-first century. It would also encourage more young designers to enter the field of type design.

The compositions opposite were done for a calendar. Each page highlighted a different version of the Stone types in a large letter that was the first letter of the name of the month, and a quotation about typography chosen by the designer, Min Wang. The visual aspect of the design appropriately dominates. The shapes of the large letters divide the space, and the text finds its home somewhere in these divisions. Whatever meaning these shapes have for us is the first message that we receive – before reading the text.

In typographic design, craft deals with

points, lines, planes, picas, ciceros,

leads, quads, serifs, letters, words, pages,

signatures, paper, ink, color, printing, and binding.

The vocabulary

of form (art)

includes, among

others:

Good design,

good typography,

Swiss or otherwise,

is a fusion of informa-

tion and inspiration, space,

of the conscious proportion,

and the unconscious, scale, site, shape,

of yesterday rhythm, repetition,

and today, sequence, movement,

of fact and balance, volume,

phantasy, contrast,

work and play, harmony, order,

craft and art. and simplicity.

Paul Rand

The task of functional
typography is to create
the typographically
designed image of our
time, one from tradition,
to activate typographical
forms as this can be
done, to find clear and
ordered forms of visual

expression, to determine
the form of new typo-
graphic assignments and
methods (for instance,
collotype, techniques such
as machine composition,
photosetting, etcetera),
and to break the hold of
craftsmanship.

Piet Zwart

A DAY IN THE LIFE OF A STUDENT

12:00 pm 3:00 pm 6:00 pm 9:00 pm

w a l k i n g

shopping

talking

working

w o r k i n g

reading

dinner walking working

walki

12:00 am

3:00 am

6:00 am

9:00 am

12:00pm

breakfast-lunch

talking

watching television

reading

sleeping

snack

dreaming
sleeping

Looking at Stone

ABCDEFGHIJKLMNOPQRSTONE

Looking at Stone

The tradition of assembling and displaying typeface specimens as a working tool for typographers is an old and rich one. For me the word *specimen* conjures up images of a careful procedure in which things are collected, classified, and catalogued so that they can be taken out again and again for study and evaluation. I associate the custom of making and using type specimens with the systematic approach of science and mathematics.

The specimens of the Stone family presented in this section are of necessity only a small subset of the possible showings. With the current technology it is possible to produce an enormous number of type variations. We can control size, leading, and line length over a gigantic range and in the tiniest increments. We can play with the shapes of the characters: they can be expanded or condensed (stretched or squeezed horizontally), imaged as outlines, stroked and filled in various ways, and more. We could fill many volumes with specimens of only a single typeface.

Given this seemingly limitless number of possibilities, it is necessary to narrow the field to a manageable but representative collection of samples. To compile the most useful reference of the Stone family, Brian and I focused on sizes and leadings that are commonly chosen and that therefore seemed to have the widest applicability. The showings of various letterspacings, expanded and condensed type, reversed type, and typeface combinations have not traditionally been included in specimen books; they are presented here because the current technology makes them accessible choices.

During an actual project, of course, we can use a computer, the appropriate software, and a laser printer to take a quick look at the typefaces in different sizes, leadings, line lengths, and so on. This capability is a welcome supplement to published displays of type specimens, but it does not replace them. First, the specimens provide an overview of an entire type family, enabling us to make broad initial choices. Second, with printed type specimens we can see a typeface in its full refinement. (Laser-printed proofs do not provide this degree of definition.) Third, the specimens can serve as an aid to our memory of previous uses of the typefaces – of their strengths and weaknesses, their feeling at different sizes, the forms of letters we may want to use in a title, and many other details. Knowing a type family well takes time and dedication, and specimen books are helpful companions in this endeavor.

What should we look for in examining a type family? Users of the Stone Family may want to consider the following kinds of questions: Which leadings do you like? Which are the easiest to read? Which sizes do you like and dislike? How does the type feel at a large as opposed to a small size? How does it look in blocks? What strikes you about the shapes and about the texture, or feeling, of the type as you run your eyes over it? (For a key to the abbreviations used to label the specimens, see page 107.)

Typefaces are for the typographer what plants are for the gardener. To make a beautiful garden, each plant must be a friend. To create beautiful typography, each typeface, and indeed each letter, must be a friend.

A SPECIMEN

By WILLIAM CASLON, Letter-Founder, in Chiſwell-Street, LONDON.

ABCD
ABCDE
ABCDEF
ABCDEFGH
ABCDEFGHI
ABCDEFGHIJK
ABCDEFGHIJKL
ABCDEFGHIKLMN

French Cannon.

Quouſque tan-
dem abutere,
Catilina, pati-
Quouſque tandem

abutere, Catilina,
patientia noſtra?

Two Lines Great Primer.

Quouſque tandem
abutere, Catilina,
patientia noſtra?
quamdiu nos etiam

Quouſque tandem a-
butere, Catilina, pa-
tientia noſtra? quam-
diu nos etiam furor

Two Lines English.

Quouſque tandem abu-
tere, Catilina, patientia
noſtra? quamdiu nos e-
tiam furor iſte tuus elu-
Quouſque tandem abutere,
Catilina, patientia noſtra?
quamdiu nos etiam furor

DOUBLE PICA ROMAN.

Quouſque tandem abutere, Cati-
lina, patientia noſtra? quamdiu
nos etiam furor iſte tuus eludet?
quem ad finem ſeſe effrenata jac-
ABCDEFGHJKLMNOP

GREAT PRIMER ROMAN.

Quouſque tandem abutère, Catilina, pa-
tientià noſtra? quamdiu nos etiam fu-
ror iſte tuus eludet? quem ad finem ſe-
ſe effrenata jactabit audacia? nihilne te
nocturnum præſidium palatii, nihil ur-
bis vigiliæ, nihil timor populi, nihil con-
ABCDEFGHIJKLMNOPQRS

ENGLISH ROMAN.

Quouſque tandem abutere, Catilina, patientia
noſtra? quamdiu nos etiam furor iſte tuus eludet?
quem ad finem ſeſe effrenata jactabit audacia?
nihilne te nocturnum præſidium palatii, nihil
urbis vigiliæ, nihil timor populi, nihil conſen-
ſus bonorum omnium, nihil hic munitiſſimus
ABCDEFGHIJKLMNOPQRSTVUW

PICA ROMAN.

Melium, novis rebus ſtudentem, manu ſua occidit.
Fuit, fuit iſta quondam in hac repub. virtus, ut viri
fortes acrioribus ſuppliciis civem perniciofum, quam
acerbiſſimum hoſtem coërcerent. Habemus enim ſe-
natuſconſultum in te, Catilina, vehemens, & grave:
non deeſt reip. conſilium, neque autoritas hujus ordi-
nis: nos, nos, dico aperte, conſules deſumus. De-
ABCDEFGHIJKLMNOPQRSTVUWX

SMALL PICA ROMAN. No 1.

At nos vigeſimum jam diem patimur hebeſcere aciem horum
autoritatis. habemus enim hujuſmodi ſenatuſconſultum, ve-
rumtamen incluſum in tabulis, tanquam gladium in vagina
reconditum: quo ex ſenatuſconſulto confeſtim interſectum te
eſſe, Catilina, convenit. Vivis: & vivis non ad deponen-
dam, ſed ad confirmandam audaciam. Cupio, P. C., me
eſſe clementem: cupio in tantis reipub. periculis non diſ-
ABCDEFGHIJKLMNOPQRSTVUWXYZ

SMALL PICA ROMAN. No 2.

At nos vigeſimum jam diem patimur hebeſcere aciem horum
autoritatis. habemus enim hujuſmodi ſenatuſconſultum, ve-
rumtamen incluſum in tabulis, tanquam gladium in vagina
reconditum: quo ex ſenatuſconſulto confeſtim interſectum te
eſſe, Catilina, convenit. Vivis: & vivis non ad deponendam,
ſed ad confirmandam audaciam. Cupio, P. C., me eſſe
clementem: cupio in tantis reipub. periculis non diſſolutum
ABCDEFGHIJKLMNOPQRSTVUWXYZ

LONG PRIMER ROMAN No 1.

Verum ego hoc, quod jampridem factum eſſe oportuit, certa de
cauſſa nondum adducor ut faciam. tum denique interficiam te, cum
jam nemo tam improbus, tam perditus, tam tui ſimilis inveniri po-
terit, qui id non jure factum eſſe fateatur. Quamdiu quiſquam erit
qui te defendere audeat, vives: & vives, ita ut nunc vivis, multis
mei. & firmis præſidiis obſeſſus, ne commovere te contra rempub.
poſſis. multorum te etiam oculi & aures non ſentientem, ſicut adhuc
fecerunt, ſpeculabuntur, atque cuſtodient. Etenim quid eſt, Cati-
ABCDEFGHIJKLMNOPQRSTVUWXYZÆ

LONG PRIMER ROMAN. No 2.

Verum ego hoc, quod jampridem factum eſſe oportuit, certa de
cauſſa nondum adducor ut faciam. tum denique interficiam te, cum
jam nemo tam improbus, tam perditus, tam tui ſimilis inveniri po-
rit, qui id non jure factum eſſe fateatur. Quamdiu quiſquam erit
qui te defendere audeat, vives: & vives, ita ut nunc vivis, multis
meis & firmis præſidiis obſeſſus, ne commovere te contra rempub.
poſſis. multorum te etiam oculi & aures non ſentientem, ſicut adhuc
fecerunt, ſpeculabuntur, atque cuſtodient. Etenim quid eſt, Cati-
ABCDEFGHIJKLMNOPQRSTVUWXYZÆ

BREVIER ROMAN.

Novemb. C. Manlium audaciæ ſatellitem atque adminiſtrum tuæ? num me fefellit,
Catilina, n m ſo ra tanta,tam atrox, tam incredibilis, verum, id quod multo
magis eſt admirandum, dies? Dixi ego idem in ſenatu, cædem te optimatum con-
tulile in ante diem v Kalend. Novemb. tum cum multi principes civitatis Rom.
non tam ſui conſervandi, quam tuorum conſiliorum reprimendorum cauſà profu-
gerunt. num inniciari potes, te illo ipſo die meis præſidiis, mea diligentia circum-
cluſum, commovere te contra rempub. non potuiſſe; cum tu diſceſſu cæterorum,
noſtra tamen, qui remanſiſſemus, cæde contentum te eſſe dicebas? Quid? cum te
ABCDEFGHIKLMNOPQRSTVUWXYZÆ

NONPAREIL ROMAN.

O di immortale s! ubi-nam gentium ſumus? quam rempub. habemus? in qua urbe vivimus?
hic, hic ſunt in noſtro num ro, P. C. in hoc orbis terræ ſanctiſſimo graviſſimoque conſilio, qui
de meo, noſtrum omnium interitu, qui de hujus urbis, at que adeo orbis terrarum exitio co-
gitent, hoſc e go video conſul, & de repub. ſententiam rogo, & quos ferro trucidari oportebat,
eos nondum voce vulnero. Fuiſti igitur apud Leccam ex nocte, Catilina, diſtribuiſti partes Ita-
liæ: ſtatuiſti quo quemque proficiſci placeret: delegiſti quos Romæ relinqueres, quos tecum
educeres: deſcripſiſti urbis partes ad incendia: confirmaſti, te ipſum jam eſſe exiturum: dixiſti
paululum tibi eſſe etiam tum moræ, quod ego viverem. Reperti duo equites Romani, qui te
iſta cura liberarent, & ſe illa ipſa nocte paulo ante lucem me in meo lecto interfecturos
polliceantur. Hæc ego omnia, vixdum etiam cœtu veſtro dimiſſo, comperi; domum meam
ABCDEFGHIKLMNOPQRSTVUWXYZÆ

DOUBLE PICA ITALICK.

Quouſque tandem abutere, Cati-
na, patientia noſtra? quamdiu
nos etiam furor iſte tuus eludet?
quem ad finem ſeſe effrenata jac-
ABCDEFGHJIKLMNO

GREAT PRIMER ITALICK.

Quouſque tandem abutére, Catilina, pa-
tientia noſtra? quamdiu nos etiam fur-
ror iſte tuus eludet? quem ad finem ſeſe
effrenata jactabit audacia? nihilne te
nocturnum præſidium palatii, nihil ur-
bis vigiliæ, nihil timor populi, nihil con-
ABCDEFGHIJKLMNOPQR

ENGLISH ITALICK.

Quouſque tandem abutere, Catilina, patientia noſ-
tra? quamdiu nos etiam furor iſte tuus eludet?
quem ad finem ſeſe effrenata jactabit audacia?
nihilne te nocturnum præſidium palatii, nihil ur-
bis vigiliæ, nihil timor populi, nihil conſenſus bo-
norum omnium, nihil hic munitiſſimus habendi ſe-
ABCDEFGHIJKLMNOPQRSTVUW

PICA ITALICK.

Melium, novis rebus ſtudentem, manu ſua occidit.
Fuit, fuit iſta quondam in hac repub. virtus, ut viri
fortes acrioribus ſuppliciis civem perniciofam, quam
acerbiſſimum hoſtem coërcerent. Habemus enim ſenatuſ-
conſultum in te, Catilina, vehemens, & grave: non deeſt
reip. conſilium, neque autoritas hujus ordinis: nos, nos,
dico aperte, conſules deſumus. Decrevit quondam ſenatus
ABCDEFGHIJKLMNOPQRSTVUWXYZ

SMALL PICA ITALICK. No 1.

At nos vigeſimum jam diem patimur hebeſcere aciem horum
autoritatis. habemus enim hujuſmodi ſenatuſconſultum, verum-
tamen incluſum in tabulis, tanquam gladium in vagina recon-
ditum: quo ex ſenatuſconſulto confeſtim interſectum te eſſe, Cati-
lina, convenit. Vivis: & vivis non ad deponendam, ſed ad
confirmandam audaciam. Cupio, P. C., me eſſe clementem:
cupio in tantis reipub. periculis non diſſolutum videri: ſed jam
ABCDEFGHIJKLMNOPQRSTVUWXYZ

SMALL PICA ITALICK. No 2.

At nos vigeſimum jam diem patimur hebeſcere aciem horum au-
toritatis. habemus enim hujuſmodi ſenatuſconſultum, verumtamen
incluſum in tabulis, tanquam gladium in vagina reconditum:
quo ex ſenatuſconſulto confeſtim interſectum te eſſe, Catilina, con-
venit. Vivis: & vivis non ad deponendam, ſed ad confirman-
dam audaciam. Cupio, P. C., me eſſe clementem: cupio in tantis
reipub. periculis non diſſolutum videri: ſed jam meipſum inertiæ
ABCDEFGHIJKLMNOPQRSTVUWXYZ

LONG PRIMER ITALICK. No 1.

Verum ego hoc, quod jampridem factum eſſe oportuit, certa de cauſſa
nondum adducor ut faciam. tum denique interficiam te, cum jam nemo
tam improbus, tam perditus, tam tui ſimilis inveniri poterit, qui id
non jure factum eſſe fateatur. Quamdiu quiſquam erit qui te defen-
dere audeat, vives: & vives, ita ut nunc vivis, multis meis &
firmis præſidiis obſeſſus, ne commovere te contra rempub. poſſis. multo-
rum te etiam oculi & aures non ſentientem, ſicut adhuc fecerunt, ſpe-
culabuntur, atque cuſtodient. Etenim quid eſt, Catilina, quod jam
ABCDEFGHIJKLMNOPQRSTVUWXYZÆ

LONG PRIMER ITALICK. No 2.

Verum ego hoc, quod jampridem factum eſſe oportuit, certa de cauſſa
nondum adducor ut faciam. tum denique interficiam te, cum jam nemo
tam improbus, tam perditus, tam tui ſimilis inveniri poterit, qui id
non jure factum eſſe fateatur. Quamdiu quiſquam erit qui te defendere
audeat, vives: & vives, ita ut nunc vivis, multis meis & firmis
præſidiis obſeſſus, ne commovere te contra rempub. poſſis. multorum te
etiam oculi & aures non ſentientem, ſicut adhuc fecerunt, ſpeculabuntur,
atque cuſtodient. Etenim quid eſt, Catilina, quod jam amplius expectes,
ABCDEFGHIJKLMNOPQRSTVUWXYZÆ

BREVIER ITALICK.

Novemb. C. Manlium audaciæ ſatellitem atque adminiſtrum tuæ? num me fefellit,
Catilina, non mo ra tanta,tam atrox, tam incredibilis, verum, id quod multo magis
eſt admirandum, dies? Dixi ego idem in ſenatu, cædem te optimatum contuliſſe in ante
v Kalend. Novemb. tum cum multi principes civitatis Rom. non tam ſui conſer-
vandi, quam tuorum conſiliorum reprimendorum cauſà profugerunt. num inniciari potes,
te illo ipſo die meis præſidiis, mea diligentia circumcluſum, commovere te contra rempub.
non potuiſſe; cum tu diſceſſu cæterorum, noſtra tamen, qui remanſiſſemus, cæde contentam
te eſſe dicebas? Quid? cum te ipſum Kalend. ipſis Novembris x cuparorum infiſſem
ABCDEFGHIJKLMNOPQRSTVUWXYZÆ

NONPAREIL ITALICK.

O di immortales! ubi-nam gentium ſumus? quam rempub. habemus? in qua urbe vivimus? hic, hic ſunt
in noſtro numero, P. C. in hoc orbis terræ ſanctiſſimo graviſſimoque conſilio, qui de meo, noſtrum omnium
interitu, qui de hujus urbis, atque adeo orbis terrarum exitio cogitent, hofce ego video conſul, & de repub.
ſententiam rogo, & quos ferro trucidari oportebat, eos nondum voce vulnero. Fuiſti igitur apud Leccam ex
nocte, Catilina, diſtribuiſti partes Italiæ: ſtatuiſti quo quemque proficiſci placeret: delegiſti quos Romæ relin-
queres, quos tecum educeres: deſcripſiſti urbis partes ad incendia: confirmaſti, te ipſum jam eſſe exiturum:
dixiſti paululum tibi eſſe etiam tum moræ, quod ego viverem. Reperti duo equites Romani, qui te iſta cura
liberarent, & ſe illa ipſa nocte paulo ante lucem me in meo lecto interfecturos polliceantur. Hæc ego omnia,
ABCDEFGHIJKLMNOPQRSTVUWXYZ

Pica Black.

And be it further enacted by the Authority
aforeſaid, That all and every of the ſaid Ex-
chequer Bills to be made forth by virtue of
this Act, or ſo many of them as ſhall from
ABCDEFGHIJKLMNOPQRST

Brevier Black.

And be it further enacted by the Authority aforeſaid, That all and every
of the ſaid Exchequer Bills to be made forth by virtue of this Act, or ſo
many of them as ſhall from time to time remain undiſcharged and uncan-
celled, until the diſcharging and cancelling the ſame purſuant to this Act.

Pica Gothick.

ATTA NNSAR ÞU IN HIMINAM VEIHNAI
NAMÆ ÞEIN UIMAI ÞINDINASSNS ÞEINS
VAIKÞAI VIAGA ÞEINS SVE IN HIMINA

Pica Coptick.

ϨΕΝ ΟΥΑΡΧΗ Αϥτ ΘΑΜΙΟ ΝΤϤΕ ΝΕΜ ΠΚ-
ΑϨΙ- ΠΚΑϨΙ ΔΕ ΝΕ ΟΥΛΘΝΑΤ ΕΡΟϤ ΠΕ ΟΥΟϨ
ΝΑΤСОВТ ΟΥΧΑΚΙ ΝΑϥΧΗ ΕΧΕΝ ΦΝΟΥΝ ΟΥΟϨ
ОҮПНА ΝΤΕϤΤ ΝΑϤΝΗΟΥ ϨΙΖΕΝ ΝΙΜΩΟΥ- О-

Pica Armenian.

Ուրաք Թագաւորք երկրի և ծովու, որդ անձին\
և պատանիք որպէս և է իսկ մեր Կատողիկ\
իսկ երկուն և պատմասէրին 'ի վեր թագ բան բնաւ\
Թագաւորաց և Թագ իշխանին, որպէս երկիր

English Syriack.

[Syriac text]

Pica Samaritan.

[Samaritan text]

English Arabick.

[Arabic text]

Hebrew with Points.

בְּרֵאשִׁית בָּרָא אֱלֹהִים אֵת הַשָּׁמַיִם וְאֵת הָאָרֶץ׃ וְהָאָרֶץ
הָיְתָה תֹהוּ וָבֹהוּ וְחֹשֶׁךְ עַל־פְּנֵי תְהוֹם וְרוּחַ אֱלֹהִים
מְרַחֶפֶת עַל־פְּנֵי הַמָּיִם׃ וַיֹּאמֶר אֱלֹהִים יְהִי אוֹר וַיְהִי־אוֹר׃
וַיַּרְא אֱלֹהִים אֶת־הָאוֹר כִּי־טוֹב וַיַּבְדֵּל אֱלֹהִים בֵּין הָאוֹר
וּבֵין הַחֹשֶׁךְ׃ וַיִּקְרָא אֱלֹהִים לָאוֹר יוֹם וְלַחֹשֶׁךְ קָרָא לָיְלָה

Hebrew without Points.

בראשית ברא אלהים את השמים ואת הארץ׃ והארץ
היתה תהו ובהו וחשך על־פני תהום ורוח אלהים
מרחפת על־פני המים׃ ויאמר אלהים יהי אור ויהי־אור׃
וירא אלהים את־האור כי־טוב ויבדל אלהים בין האור
ובין החשך׃ ויקרא אלהים לאור יום ולחשך קרא לילה

Brevier Hebrew.

בראשית ברא אלהים את השמים ואת הארץ׃ והארץ היתה תהו
ובהו וחשך על־פני תהום ורוח אלהים מרחפת על־פני המים׃ ויאמר
אלהים יהי אור ויהי־אור׃ וירא אלהים את־האור כי־טוב
ויבדל אלהים בין האור ובין החשך׃ ויקרא אלהים לאור יום

English Greek.

Πρόδικος ὁ σοφὸς ἐν τῷ συγγράμματι τῷ περὶ τῷ Ἡρα-
κλέους (ὅπερ δὴ καὶ πλείστοις ἐπιδείκνυται) ὕτω περὶ τῆς
ἀρετῆς ἀποφαίνεται, ὡδί πως λέγων, ὅσα ἐγὼ μέμνημαι.
φησὶ μὲν Ἡρακλέα, ἐπεὶ ἐκ παίδων εἰς ἥβην ὡρμᾶτο,
(ἐν ᾗ οἱ νέοι ἤδη αὐτοκράτορες γιγνόμενοι δηλοῦσιν, εἴτε τὴν

Pica Greek.

Πρόδικος ὁ σοφὸς ἐν τῷ συγγράμματι τῷ περὶ τῷ Ἡρακλέους
(ὅπερ δὴ καὶ πλείστοις ἐπιδείκνυται) ὕτω περὶ τῆς ἀρετῆς
Φαίνεται, ὡδί πως λέγων, ὅσα ἐγὼ μέμνημαι· φησὶ μὲν
Ἡρακλέα, ἐπεὶ ἐκ παίδων εἰς ἥβην ὡρμᾶτο, (ἐν ᾗ οἱ νέοι ἤδη
αὐτοκράτορες γιγνόμενοι δηλοῦσιν, εἴτε τὴν δι᾽ ἀρετῆς ὁδὸν τρέψονται

Long Primer Greek.

Πρόδικος ὁ σοφὸς ἐν τῷ συγγράμματι τῷ περὶ τῷ Ἡρακλέους (ὅπερ δὴ καὶ
πλείστοις ἐπιδείκνυται) ὕτω περὶ τῆς ἀρετῆς ἀποφαίνεται, ὡδί πως λέγων,
ὅσα ἐγὼ μέμνημαι· φησὶ μὲν Ἡρακλέα, ἐπεὶ ἐκ παίδων εἰς ἥβην ὡρμᾶτο,
(ἐν ᾗ οἱ νέοι ἤδη αὐτοκράτορες γιγνόμενοι δηλοῦσιν, εἴτε τὴν δι᾽ ἀρετῆς ὁδὸν

Brevier Greek.

[Brevier Greek text]

Pica Roman. / Pearl Italic.

[small text samples]

Long Primer Saxon.

Ða he ꝺa miꝺ ᵹrimmum
neᵹum paeceꝺ pær ꞃ he ealle þa
pꞇu ꝺe nim manꞇbyꝺe ᵹehyoleꞇe
þeꞅbenꝺe ꞃoꞃ byrne aben an

Pica Saxon.

Ða he ꝺa miꝺ ᵹrimmum
neᵹum paeceꝺ pær ꞃ he ealle þa
ꝼpinᵹlum ꞃ ꞇinꞇneᵹum þæ
ceꝺ þær ꞃ he ealle þa piꞇu

STONE SERIF

Medium

ABCDEFGHIJKLMNOPQRSTUVWXYZ

abcdefghijklmnopqrstuvwxyz

fiflß æœ ÆŒ åèíöûñç ÅÈÍÖÛÑÇ

1234567890& .,:;''""-–—?!/)]}‹›«»

$¢£¥ƒ†‡*§¶%@#

Semibold

ABCDEFGHIJKLMNOPQRSTUVWXYZ

abcdefghijklmnopqrstuvwxyz

fiflß æœ ÆŒ åèíöûñç ÅÈÍÖÛÑÇ

1234567890& .,:;''""-–—?!/)]}‹›«»

$¢£¥ƒ†‡*§¶%@#

Bold

ABCDEFGHIJKLMNOPQRSTUVWXYZ

abcdefghijklmnopqrstuvwxyz

fiflß æœ ÆŒ åèíöûñç ÅÈÍÖÛÑÇ

1234567890& .,:;''""-–—?!/)]}‹›«»

$¢£¥ƒ†‡*§¶%@#

Medium Italic

ABCDEFGHIJKLMNOPQRSTUVWXYZ

abcdefghijklmnopqrstuvwxyz

fiflß æœ ÆŒ åèíöûñç ÅÈÍÖÛÑÇ

1234567890& .,:;'"""-–—?!/)]}‹›«»

$¢£¥ƒ†‡*§¶%@#

Semibold Italic

ABCDEFGHIJKLMNOPQRSTUVWXYZ

abcdefghijklmnopqrstuvwxyz

fiflß æœ ÆŒ åèíöûñç ÅÈÍÖÛÑÇ

1234567890& .,:;'"""-–—?!/)]}‹›«»

$¢£¥ƒ†‡*§¶%@#

Bold Italic

ABCDEFGHIJKLMNOPQRSTUVWXYZ

abcdefghijklmnopqrstuvwxyz

fiflß æœ ÆŒ åèíöûñç ÅÈÍÖÛÑÇ

1234567890& .,:;'"""-–—?!/)]}‹›«»

$¢£¥ƒ†‡*§¶%@#

8/9, 19p2 max line length

Alphabetic forms are conventions; letters must be recognizable or alphabetic communication is impossible. The *requirements of legibility* make the graphic designer's work possible. In the arts, freedom implies a certain boldness of invention and originality, a freshness and grace, a liveliness of rhythmical movement. Are the formal requirements of alphabet and page design in a dialectical opposition to freedom? Not if the designer has mastered them. He makes the requirement

8/10

Alphabetic forms are conventions; letters must be recognizable or alphabetic communication is impossible. The *requirements of legibility* make the graphic designer's work possible. In the arts, freedom implies a certain boldness of invention and originality, a freshness and grace, a liveliness of rhythmical movement. Are the formal requirements of alphabet and page design in a dialectical opposition to freedom? Not if the designer has mastered them. He makes the requirement

8/11

Alphabetic forms are conventions; letters must be recognizable or alphabetic communication is impossible. The *requirements of legibility* make the graphic designer's work possible. In the arts, freedom implies a certain boldness of invention and originality, a freshness and grace, a liveliness of rhythmical movement. Are the formal requirements of alphabet and page design in a dialectical opposition to freedom? Not if the designer has mastered them. He makes the requirement

8/12

Alphabetic forms are conventions; letters must be recognizable or alphabetic communication is impossible. The *requirements of legibility* make the graphic designer's work possible. In the arts, freedom implies a certain boldness of invention and originality, a freshness and grace, a liveliness of rhythmical movement. Are the formal requirements of alphabet and page design in a dialectical opposition to freedom? Not if the designer has mastered them. He makes the requirement

Serif Medium

8/13

Alphabetic forms are conventions; letters must be recognizable or alphabetic communication is impossible. The *requirements of legibility* make the graphic designer's work possible. In the arts, freedom implies a certain boldness of invention and originality, a freshness and grace, a liveliness of rhythmical movement. Are the formal requirements of alphabet and page design in a dialectical opposition to freedom? Not if the designer has mastered them. He makes the requirement

8/14

Alphabetic forms are conventions; letters must be recognizable or alphabetic communication is impossible. The *requirements of legibility* make the graphic designer's work possible. In the arts, freedom implies a certain boldness of invention and originality, a freshness and grace, a liveliness of rhythmical movement. Are the formal requirements of alphabet and page design in a dialectical opposition to freedom? Not if the designer has mastered them. He makes the requirement

8/15

Alphabetic forms are conventions; letters must be recognizable or alphabetic communication is impossible. The *requirements of legibility* make the graphic designer's work possible. In the arts, freedom implies a certain boldness of invention and originality, a freshness and grace, a liveliness of rhythmical movement. Are the formal requirements of alphabet and page design in a dialectical opposition to freedom? Not if the designer has mastered them. He makes the requirement

9/10, 19p2 max line length

Alphabetic forms are conventions; letters must be recognizable or alphabetic communication is impossible. The *requirements of legibility* make the graphic designer's work possible. In the arts, freedom implies a certain boldness of invention and originality, a freshness and grace, a liveliness of rhythmical movement. Are the formal requirements of alphabet and page design in a dialectical opposition to freedom? Not if the de-

9/11

Alphabetic forms are conventions; letters must be recognizable or alphabetic communication is impossible. The *requirements of legibility* make the graphic designer's work possible. In the arts, freedom implies a certain boldness of invention and originality, a freshness and grace, a liveliness of rhythmical movement. Are the formal requirements of alphabet and page design in a dialectical opposition to freedom? Not if the de-

9/12

Alphabetic forms are conventions; letters must be recognizable or alphabetic communication is impossible. The *requirements of legibility* make the graphic designer's work possible. In the arts, freedom implies a certain boldness of invention and originality, a freshness and grace, a liveliness of rhythmical movement. Are the formal requirements of alphabet and page design in a dialectical opposition to freedom? Not if the de-

9/13

Alphabetic forms are conventions; letters must be recognizable or alphabetic communication is impossible. The *requirements of legibility* make the graphic designer's work possible. In the arts, freedom implies a certain boldness of invention and originality, a freshness and grace, a liveliness of rhythmical movement. Are the formal requirements of alphabet and page design in a dialectical opposition to freedom? Not if the de-

9/14

Alphabetic forms are conventions; letters must be recognizable or alphabetic communication is impossible. The *requirements of legibility* make the graphic designer's work possible. In the arts, freedom implies a certain boldness of invention and originality, a freshness and grace, a liveliness of rhythmical movement. Are the formal requirements of alphabet and page design in a dialectical opposition to freedom? Not if the de-

9/15

Alphabetic forms are conventions; letters must be recognizable or alphabetic communication is impossible. The *requirements of legibility* make the graphic designer's work possible. In the arts, freedom implies a certain boldness of invention and originality, a freshness and grace, a liveliness of rhythmical movement. Are the formal requirements of alphabet and page design in a dialectical opposition to freedom? Not if the de-

Alphabetic forms are conventions; letters must be recognizable or alphabetic communication is impossible. The *requirements of legibility* make the graphic designer's work possible. In the arts, freedom implies a certain boldness of invention and originality, a freshness and grace, a liveliness of rhythmical movement. Are the formal requirements of alphabet and page design in a dialectic-

Alphabetic forms are conventions; letters must be recognizable or alphabetic communication is impossible. The *requirements of legibility* make the graphic designer's work possible. In the arts, freedom implies a certain boldness of invention and originality, a freshness and grace, a liveliness of rhythmical movement. Are the formal requirements of alphabet and page design in a dialectic-

Alphabetic forms are conventions; letters must be recognizable or alphabetic communication is impossible. The *requirements of legibility* make the graphic designer's work possible. In the arts, freedom implies a certain boldness of invention and originality, a freshness and grace, a liveliness of rhythmical movement. Are the formal requirements of alphabet and page design in a dialectic-

Alphabetic forms are conventions; letters must be recognizable or alphabetic communication is impossible. The *requirements of legibility* make the graphic designer's work possible. In the arts, freedom implies a certain boldness of invention and originality, a freshness and grace, a liveliness of rhythmical movement. Are the formal requirements of alphabet and page design in a dialectic-

Alphabetic forms are conventions; letters must be recognizable or alphabetic communication is impossible. The *requirements of legibility* make the graphic designer's work possible. In the arts, freedom implies a certain boldness of invention and originality, a freshness and grace, a liveliness of rhythmical movement. Are the formal requirements of alphabet and page design in a dialectic-

Alphabetic forms are conventions; letters must be recognizable or alphabetic communication is impossible. The *requirements of legibility* make the graphic designer's work possible. In the arts, freedom implies a certain boldness of invention and originality, a freshness and grace, a liveliness of rhythmical movement. Are the formal requirements of alphabet and page design in a dialectical opposition to freedom? Not if the designer has mastered them. He makes the requirement a means to freedom. What a difference it might make to

Alphabetic forms are conventions; letters must be recognizable or alphabetic communication is impossible. The *requirements of legibility* make the graphic designer's work possible. In the arts, freedom implies a certain boldness of invention and originality, a freshness and grace, a liveliness of rhythmical movement. Are the formal requirements of alphabet and page design in a dialectical opposition to freedom? Not if the designer has mastered them. He makes the requirement a means to freedom. What a difference it might make to

Alphabetic forms are conventions; letters must be recognizable or alphabetic communication is impossible. The *requirements of legibility* make the graphic designer's work possible. In the arts, freedom implies a certain boldness of invention and originality, a freshness and grace, a liveliness of rhythmical movement. Are the formal requirements of alphabet and page design in a dialectical opposition to freedom? Not if the designer has mastered them. He makes the requirement a means to freedom. What a difference it might make to

Alphabetic forms are conventions; letters must be recognizable or alphabetic communication is impossible. The *requirements of legibility* make the graphic designer's work possible. In the arts, freedom implies a certain boldness of invention and originality, a freshness and grace, a liveliness of rhythmical movement. Are the formal requirements of alphabet and page design in a dialectical opposition to freedom? Not if the designer has mastered them. He makes the requirement a means to freedom. What a difference it might make to

Alphabetic forms are conventions; letters must be recognizable or alphabetic communication is impossible. The *requirements of legibility* make the graphic designer's work possible. In the arts, freedom implies a certain boldness of invention and originality, a freshness and grace, a liveliness of rhythmical movement. Are the formal require ments of alphabet and page design in a dialectical opposition to freedom? Not if the designer has mastered them. He makes the requirement a means to freedom. What a

13/16

Alphabetic forms are conventions; letters must be recognizable or alphabetic communication is impossible. The *requirements of legibility* make the graphic designer's work possible. In the arts, freedom implies a certain boldness of invention and originality, a freshness and grace, a liveliness of rhythmical movement. Are the formal requirements of alphabet and page design in a dialectical opposition to freedom? Not if the designer has mastered them. He makes the

14/17

Alphabetic forms are conventions; letters must be recognizable or alphabetic communication is impossible. The *requirements of legibility* make the graphic designer's work possible. In the arts, freedom implies a certain boldness of invention and originality, a freshness and grace, a liveliness of rhythmical movement. Are the formal requirements of alphabet and page design in a dialectical opposition to freedom? Not if the designer has mas-

16/19

Alphabetic forms are conventions; letters must be recognizable or alphabetic communication is impossible. The *requirements of legibility* make the graphic designer's work possible. In the arts, freedom implies a certain boldness of invention and originality, a freshness and grace, a liveliness of rhythmical movement. Are the formal requirements of alphabet and page design in a dialec-

18/21

Alphabetic forms are conventions; letters must be recognizable or alphabetic communication is impossible. The *requirements of legibility* make the graphic designer's work possible. In the arts, freedom implies a certain boldness of invention and originality, a freshness and grace, a liveliness of rhythmical movement. Are the formal require-

20/24

Alphabetic forms are conventions; letters must be recognizable or alphabetic communication is impossible. The *requirements of legibility* make the graphic designer's work possible. In the arts, freedom implies a certain boldness of invention and originality, a freshness and grace, a liveliness of rhythmical

24 Alphabetic forms are conventions; letters m

30 Alphabetic forms are conventions;

36 Alphabetic forms are convent

42 Alphabetic forms are con

48 Alphabetic forms are c

54 Alphabetic forms ar

60 Alphabetic forms

24 *Alphabetic forms are conventions; letters must b*

30 *Alphabetic forms are conventions; lett*

36 *Alphabetic forms are convention*

42 *Alphabetic forms are conve*

48 *Alphabetic forms are co*

54 *Alphabetic forms are*

60 *Alphabetic forms a*

Serif Semibold

24 Alphabetic forms are conventions; letters

30 Alphabetic forms are convention

36 Alphabetic forms are conve

42 Alphabetic forms are co

48 Alphabetic forms are

54 Alphabetic forms a

60 Alphabetic form

Serif Semibold Italic

24 *Alphabetic forms are conventions; letters m*

30 *Alphabetic forms are conventions;*

36 *Alphabetic forms are conven*

42 *Alphabetic forms are con*

48 *Alphabetic forms are*

54 *Alphabetic forms a*

60 *Alphabetic forms*

Serif Bold

24 **Alphabetic forms are conventions; let**

30 **Alphabetic forms are conventi**

36 **Alphabetic forms are con**

42 **Alphabetic forms are**

48 **Alphabetic forms a**

54 **Alphabetic form**

60 **Alphabetic for**

Serif Bold Italic

24 ***Alphabetic forms are conventions; lette***

30 ***Alphabetic forms are conventio***

36 ***Alphabetic forms are conv***

42 ***Alphabetic forms are c***

48 ***Alphabetic forms a***

54 ***Alphabetic forms***

60 ***Alphabetic for***

ALPHABETIC FORMS ARE CONVENTIONS

ALPHABETIC FORMS ARE CONVENTIO

ALPHABETIC FORMS ARE CONVEN

ALPHABETIC FORMS ARE CONVE

letterspacing +0.02 em >
horizontal scaling 105% >>

Alphabetic forms are conventions; letters must be recognizable or alphabetic communication is impossible. The requirements of legibility

Alphabetic forms are conventions; letters must be recognizable or alphabetic communication is impossible. The requirements of legibility

normal >
normal >>

Alphabetic forms are conventions; letters must be recognizable or alphabetic communication is impossible. The requirements of legibility make

Alphabetic forms are conventions; letters must be recognizable or alphabetic communication is impossible. The requirements of legibility make

−0.02 em >
95% >>

Alphabetic forms are conventions; letters must be recognizable or alphabetic communication is impossible. The requirements of legibility make the

Alphabetic forms are conventions; letters must be recognizable or alphabetic communication is impossible. The requirements of legibility make the

−0.04 em >
90% >>

Alphabetic forms are conventions; letters must be recognizable or alphabetic communication is impossible. The requirements of legibility make the graphic de-

Alphabetic forms are conventions; letters must be recognizable or alphabetic communication is impossible. The requirements of legibility make the graphic de-

word spacing
normal (0.2875 em)

Alphabetic forms are conventions; letters m

0.250 em

Alphabetic forms are conventions; letters m

0.200 em

Alphabetic forms are conventions; letters m

0.167 em

Alphabetic forms are conventions; letters mu

word spacing
normal (0.2875 em)

Alphabetic forms are conventions; letters must be recognizable or alphabetic communication is impossible. The requirements of legibility make

Alphabetic forms are conventions; letters must be recognizable or alphabetic communication is impossible. The requirements of legibility make the graphic

0.250 em

Alphabetic forms are conventions; letters must be recognizable or alphabetic communication is impossible. The requirements of legibility make the

Alphabetic forms are conventions; letters must be recognizable or alphabetic communication is impossible. The requirements of legibility make the graphic de-

0.200 em

Alphabetic forms are conventions; letters must be recognizable or alphabetic communication is impossible. The requirements of legibility make the

Alphabetic forms are conventions; letters must be recognizable or alphabetic communication is impossible. The requirements of legibility make the graphic de-

0.166 em

Alphabetic forms are conventions; letters must be recognizable or alphabetic communication is impossible. The requirements of legibility make the

Alphabetic forms are conventions; letters must be recognizable or alphabetic communication is impossible. The requirements of legibility make the graphic design-

10/13 Medium > 10/13 Medium Italic >>	

Alphabetic forms are conventions; letters must be recognizable or alphabetic communication is impossible. The requirements of legibility make the graphic designer's work possible. In the arts, freedom implies a certain boldness of invention

Alphabetic forms are conventions; letters must be recognizable or alphabetic communication is impossible. The requirements of legibility make the graphic designer's work possible. In the arts, freedom implies a certain boldness of invention and originality, a

10/13 Semibold >
 10/13 Semibold Italic >>

Alphabetic forms are conventions; letters must be recognizable or alphabetic communication is impossible. The requirements of legibility make the graphic designer's work possible. In the arts, freedom implies a certain boldness of

Alphabetic forms are conventions; letters be recognizable or alphabetic communication is impossible. The requirements of legibility make the graphic designer's work possible. In the arts, freedom implies a certain boldness of invention

10/13 Bold >
 10/13 Bold Italic >>

Alphabetic forms are conventions; letters must be recognizable or alphabetic communication is impossible. The requirements of legibility make the graphic designer's work possible. In the arts, free-

Alphabetic forms are conventions; letters must be recognizable or alphabetic communication is impossible. The require-ments of legibility make the graphic design-er's work possible. In the arts, freedom

Semibold within Medium >
 Bold within Medium >>

Alphabetic forms are conventions; letters must be recognizable or alphabetic communication is impossible. The **requirements** of legibility make the graphic designer's work possible. In the arts, freedom implies a certain boldness of invention

Alphabetic forms are conventions; letters must be recognizable or alphabetic communication is impossible. The **requirements** of legibility make the graphic designer's work possible. In the arts, freedom implies a certain boldness of inven-

Bold within Semibold >
 Figures within capitals >>

Alphabetic forms are conventions; letters must be recognizable or alphabetic communication is impossible. The requirements of legibility make the graphic designer's work possible. In the arts, freedom implies a certain boldness of

ALPHABETIC FORMS ARE CONVENTIONS; LETTERS MUST BE RECOGNIZABLE OR 48 ALPHABETIC COMMUNICATION IS IMPOSSIBLE. THE REQUIREMENTS $20,765 OF LEGIBILITY MAKE THE GRAPHIC DESIGNER'S WORK POSSIBLE. IN

10 pt. figures within 10 pt. text >
 9 pt. figures within 10 pt. text >>

Alphabetic forms are conventions; letters must be recognizable or alphabetic 48 communication is impossible. The requirements of legibility make the $20,765 graphic designer's work possi-ble. In the arts, freedom implies a certain bold-

Alphabetic forms are conventions; letters must be recognizable or alphabetic 48 communication is impossible. The requirements of legibility make the $20,765 graphic designer's work possi-ble. In the arts, freedom implies a certain bold-

7.25 pt. and 10 pt. Medium capitals >
 7.25 pt. Semibold capitals >>

ALPHABETIC FORMS are conventions; letters must be recognizable or alphabetic ASCII communication is impossible. The requirements of legibility make the ASCII graphic designer's work possible. In the arts, freedom implies a certain boldness of

ALPHABETIC FORMS are conventions; letters must be recognizable or alphabetic ASCII communication is impossible. The requirements of legibility make the ASCII graphic designer's work possible. In the arts, freedom implies a certain boldness of

4/5 Medium >
 4/5 Semibold >>

Alphabetic forms are conventions; letters must be recognizable or alphabetic communication is impossible. The require-ments of legibility make the graphic designer's work possible. In the arts, freedom implies a certain boldness of invention and originality, a freshness and grace, a liveliness of rhythmical movement. Are the formal requirements of alphabet and page design in a dialectical opposition to freedom? Not if the designer has mastered them. He makes the requirement a means to freedom. What a difference it might make to elementary and secondary school students if, instead of imposing discipline as obedience on them – as if they were in the army or a penal institution, we put more effort into teaching disci-plines as skills. It would be wonderful if each schoolroom had a copy of the Disciplined Freedom broadside and the stu-dents discussed it as an illustration of how freedom can be achieved through discipline. The alphabet is an arbitrary set of signs having no visual counterpart in nature. However, it is not completely arbitrary; it is governed by cultural tradition. We can read only that writing or printed matter which employs signs with which we are familiar. Much handwriting today is illegible because the hurrying hand has failed to delineate recognizable letterforms. There are many styles of alphabets in our western culture, and many letterforms seem unrelated to their preceding forms. The lower case Roman g, for instance,

Alphabetic forms are conventions; letters must be recognizable or alphabetic communication is impossible. The requirements of legibility make the graphic designer's work possible. In the arts, freedom implies a certain boldness of invention and originality, a freshness and grace, a liveliness of rhythmical movement. Are the formal require-ments of alphabet and page design in a dialectical opposition to freedom? Not if the designer has mastered them. He makes the requirement a means to freedom. What a difference it might make to elementary and secondary school students if, instead of imposing discipline as obedience on them – as if they were in the army or a penal institution. we put more effort into teaching disciplines as skills. It would be wonderful if each schoolroom had a copy of the Disciplined Freedom broadside and the students discussed it as an illustration of how freedom can be achieved through discipline. The alphabet is an arbitrary set of signs having no visual counterpart in nature. How-ever, it is not completely arbitrary; it is governed by cultural tradition. We can read only that writing or printed matter which employs signs with which we are familiar. Much handwriting today is illegible because the hurrying hand has failed to delineate recognizable letterforms. There are many styles of alphabets in our western culture, and

5/6 Medium >
 5/6 Semibold >>

Alphabetic forms are conventions; letters must be recognizable or alphabetic communication is impossible. The requirements of legibility make the graphic designer's work possible. In the arts, freedom implies a certain boldness of invention and originality, a freshness and grace, a liveliness of rhythmical movement. Are the formal requirements of alphabet and page design in a dialectical opposition to freedom? Not if the designer has mastered them. He makes the requirement a means to freedom. What a difference it might make to elementary and secondary school students if, in-stead of imposing discipline as obedience on them – as if they were in the army or a penal institu-tion, we put more effort into teaching disciplines as skills. It would be wonderful if each school-room had a copy of the Disciplined Freedom broadside and the students discussed it as an illustra-tion of how freedom can be achieved through discipline. The alphabet is an arbitrary set of signs

Alphabetic forms are conventions; letters must be recognizable or alphabetic communication is impossible. The requirements of legibility make the graphic designer's work possible. In the arts, freedom implies a certain boldness of invention and originality, a freshness and grace, a liveliness of rhythmical movement. Are the formal requirements of alphabet and page design in a dialectical opposition to freedom? Not if the designer has mastered them. He makes the requirement a means to freedom. What a difference it might make to elemen-tary and secondary school students if, instead of imposing discipline as obedience on them – as if they were in the army or a penal institution, we put more effort into teaching disci-plines as skills. It would be wonderful if each schoolroom had a copy of the Disciplined Freedom broadside and the students discussed it as an illustration of how freedom can be

6/7 Medium >
 6/7 Semibold >>

Alphabetic forms are conventions; letters must be recognizable or alphabetic com-munication is impossible. The requirements of legibility make the graphic design-er's work possible. In the arts, freedom implies a certain boldness of invention and originality, a freshness and grace, a liveliness of rhythmical movement. Are the formal requirements of alphabet and page design in a dialectical opposition to freedom? Not if the designer has mastered them. He makes the requirement a means to freedom. What a difference it might make to elementary and secondary school students if, instead of imposing discipline as obedience on them – as if they were in the army or a penal institution, we put more effort into teaching dis-

Alphabetic forms are conventions; letters must be recognizable or alphabetic communication is impossible. The requirements of legibility make the graphic designer's work possible. In the arts, freedom implies a certain boldness of invention and originality, a freshness and grace, a liveliness of rhythmical movement. Are the formal requirements of alphabet and page design in a dialectical opposition to freedom? Not if the designer has mastered them. He makes the requirement a means to freedom. What a difference it might make to elementary and secondary school students if, instead of imposing disci-pline as obedience on them – as if they were in the army or a penal institu-

STONE SANS

Medium

ABCDEFGHIJKLMNOPQRSTUVWXYZ
abcdefghijklmnopqrstuvwxyz
fiflß æœ ÆŒ åèíöûñç ÅÈÍÖÛÑÇ
1234567890& .,:;''""-–—?!/)]}‹›«»
$¢£¥ƒ†‡*§¶%@#

Semibold

ABCDEFGHIJKLMNOPQRSTUVWXYZ
abcdefghijklmnopqrstuvwxyz
fiflß æœ ÆŒ åèíöûñç ÅÈÍÖÛÑÇ
1234567890& .,:;''""-–—?!/)]}‹›«»
$¢£¥ƒ†‡*§¶%@#

Bold

ABCDEFGHIJKLMNOPQRSTUVWXYZ
abcdefghijklmnopqrstuvwxyz
fiflß æœ ÆŒ åèíöûñç ÅÈÍÖÛÑÇ
1234567890& .,:;''""-–—?!/)]}‹›«»
$¢£¥ƒ†‡*§¶%@#

Medium Italic

ABCDEFGHIJKLMNOPQRSTUVWXYZ

abcdefghijklmnopqrstuvwxyz

fiflß œœ ÆŒ åèíöûñç ÅÈÍÖÛÑÇ

1234567890& .,:;''""- – —?!/)]}‹›«»

$¢£¥ƒ†‡*§¶%@#

Semibold Italic

ABCDEFGHIJKLMNOPQRSTUVWXYZ

abcdefghijklmnopqrstuvwxyz

fiflß œœ ÆŒ åèíöûñç ÅÈÍÖÛÑÇ

1234567890& .,:;''""- – —?!/)]}‹›«»

$¢£¥ƒ†‡*§¶%@#

Bold Italic

ABCDEFGHIJKLMNOPQRSTUVWXYZ

abcdefghijklmnopqrstuvwxyz

fiflß œœ ÆŒ åèíöûñç ÅÈÍÖÛÑÇ

1234567890& .,:;''""- – —?!/)]}‹›«»

$¢£¥ƒ†‡*§¶%@#

Most of the minuscule forms were anticipated very early in the Roman period by scribbles on wax tablets and on papyrus. It took centuries for these forms to be *accepted by the eye* and elevated to the rank of formal and semi-formal writing. Inscribing on a wax tablet with a metal stylus (a practice continuing into the Renaissance) presented difficulties. The stylus could not produce curves without breaking wax loose; so curves tended to flatten out or be replaced by straight lines. One of the most diffi-

8/10

Most of the minuscule forms were anticipated very early in the Roman period by scribbles on wax tablets and on papyrus. It took centuries for these forms to be *accepted by the eye* and elevated to the rank of formal and semi-formal writing. Inscribing on a wax tablet with a metal stylus (a practice continuing into the Renaissance) presented difficulties. The stylus could not produce curves without breaking wax loose; so curves tended to flatten out or be replaced by straight lines. One of the most diffi-

8/11

Most of the minuscule forms were anticipated very early in the Roman period by scribbles on wax tablets and on papyrus. It took centuries for these forms to be *accepted by the eye* and elevated to the rank of formal and semi-formal writing. Inscribing on a wax tablet with a metal stylus (a practice continuing into the Renaissance) presented difficulties. The stylus could not produce curves without breaking wax loose; so curves tended to flatten out or be replaced by straight lines. One of the most diffi-

8/12

Most of the minuscule forms were anticipated very early in the Roman period by scribbles on wax tablets and on papyrus. It took centuries for these forms to be *accepted by the eye* and elevated to the rank of formal and semi-formal writing. Inscribing on a wax tablet with a metal stylus (a practice continuing into the Renaissance) presented difficulties. The stylus could not produce curves without breaking wax loose; so curves tended to flatten out or be replaced by straight lines. One of the most diffi-

8/13

Sans Medium

Most of the minuscule forms were anticipated very early in the Roman period by scribbles on wax tablets and on papyrus. It took centuries for these forms to be *accepted by the eye* and elevated to the rank of formal and semi-formal writing. Inscribing on a wax tablet with a metal stylus (a practice continuing into the Renaissance) presented difficulties. The stylus could not produce curves without breaking wax loose; so curves tended to flatten out or be replaced by straight lines. One of the most diffi-

8/14

Most of the minuscule forms were anticipated very early in the Roman period by scribbles on wax tablets and on papyrus. It took centuries for these forms to be *accepted by the eye* and elevated to the rank of formal and semi-formal writing. Inscribing on a wax tablet with a metal stylus (a practice continuing into the Renaissance) presented difficulties. The stylus could not produce curves without breaking wax loose; so curves tended to flatten out or be replaced by straight lines. One of the most diffi-

8/15

Most of the minuscule forms were anticipated very early in the Roman period by scribbles on wax tablets and on papyrus. It took centuries for these forms to be *accepted by the eye* and elevated to the rank of formal and semi-formal writing. Inscribing on a wax tablet with a metal stylus (a practice continuing into the Renaissance) presented difficulties. The stylus could not produce curves without breaking wax loose; so curves tended to flatten out or be replaced by straight lines. One of the most diffi-

Most of the minuscule forms were anticipated very early in the Roman period by scribbles on wax tablets and on papyrus. It took centuries for these forms to be *accepted by the eye* and elevated to the rank of formal and semi-formal writing. Inscribing on a wax tablet with a metal stylus (a practice continuing into the Renaissance) presented difficulties. The stylus could not produce curves without breaking wax loose; so curves tended to flatten

9/11

Most of the minuscule forms were anticipated very early in the Roman period by scribbles on wax tablets and on papyrus. It took centuries for these forms to be *accepted by the eye* and elevated to the rank of formal and semi-formal writing. Inscribing on a wax tablet with a metal stylus (a practice continuing into the Renaissance) presented difficulties. The stylus could not produce curves without breaking wax loose; so curves tended to flatten

9/12

Most of the minuscule forms were anticipated very early in the Roman period by scribbles on wax tablets and on papyrus. It took centuries for these forms to be *accepted by the eye* and elevated to the rank of formal and semi-formal writing. Inscribing on a wax tablet with a metal stylus (a practice continuing into the Renaissance) presented difficulties. The stylus could not produce curves without breaking wax loose; so curves tended to flatten

9/13

Most of the minuscule forms were anticipated very early in the Roman period by scribbles on wax tablets and on papyrus. It took centuries for these forms to be *accepted by the eye* and elevated to the rank of formal and semi-formal writing. Inscribing on a wax tablet with a metal stylus (a practice continuing into the Renaissance) presented difficulties. The stylus could not produce curves without breaking wax loose; so curves tended to flatten

9/14

Most of the minuscule forms were anticipated very early in the Roman period by scribbles on wax tablets and on papyrus. It took centuries for these forms to be *accepted by the eye* and elevated to the rank of formal and semi-formal writing. Inscribing on a wax tablet with a metal stylus (a practice continuing into the Renaissance) presented difficulties. The stylus could not produce curves without breaking wax loose; so curves tended to flatten

9/15

Most of the minuscule forms were anticipated very early in the Roman period by scribbles on wax tablets and on papyrus. It took centuries for these forms to be *accepted by the eye* and elevated to the rank of formal and semi-formal writing. Inscribing on a wax tablet with a metal stylus (a practice continuing into the Renaissance) presented difficulties. The stylus could not produce curves without breaking wax loose; so curves tended to flatten

Most of the minuscule forms were anticipated very early in the Roman period by scribbles on wax tablets and on papyrus. It took centuries for these forms to be *accepted by the eye* and elevated to the rank of formal and semi-formal writing. Inscribing on a wax tablet with a metal stylus (a practice continuing into the Renaissance) presented difficulties. The stylus could not produce curves without

Most of the minuscule forms were anticipated very early in the Roman period by scribbles on wax tablets and on papyrus. It took centuries for these forms to be *accepted by the eye* and elevated to the rank of formal and semi-formal writing. Inscribing on a wax tablet with a metal stylus (a practice continuing into the Renaissance) presented difficulties. The stylus could not produce curves without

Most of the minuscule forms were anticipated very early in the Roman period by scribbles on wax tablets and on papyrus. It took centuries for these forms to be *accepted by the eye* and elevated to the rank of formal and semi-formal writing. Inscribing on a wax tablet with a metal stylus (a practice continuing into the Renaissance) presented difficulties. The stylus could not produce curves without

Most of the minuscule forms were anticipated very early in the Roman period by scribbles on wax tablets and on papyrus. It took centuries for these forms to be *accepted by the eye* and elevated to the rank of formal and semi-formal writing. Inscribing on a wax tablet with a metal stylus (a practice continuing into the Renaissance) presented difficulties. The stylus could not produce curves without

Most of the minuscule forms were anticipated very early in the Roman period by scribbles on wax tablets and on papyrus. It took centuries for these forms to be *accepted by the eye* and elevated to the rank of formal and semi-formal writing. Inscribing on a wax tablet with a metal stylus (a practice continuing into the Renaissance) presented difficulties. The stylus could not produce curves without

Most of the minuscule forms were anticipated very early in the Roman period by scribbles on wax tablets and on papyrus. It took centuries for these forms to be *accepted by the eye* and elevated to the rank of formal and semi-formal writing. Inscribing on a wax tablet with a metal stylus (a practice continuing into the Renaissance) presented difficulties. The stylus could not produce curves without breaking wax loose; so curves tended to flatten out or be replaced by straight lines. One of the most difficult letters to write on wax was the *S* (see Figure 10-1). In join-

Most of the minuscule forms were anticipated very early in the Roman period by scribbles on wax tablets and on papyrus. It took centuries for these forms to be *accepted by the eye* and elevated to the rank of formal and semi-formal writing. Inscribing on a wax tablet with a metal stylus (a practice continuing into the Renaissance) presented difficulties. The stylus could not produce curves without breaking wax loose; so curves tended to flatten out or be replaced by straight lines. One of the most difficult letters to write on wax was the *S* (see Figure 10-1). In join-

Most of the minuscule forms were anticipated very early in the Roman period by scribbles on wax tablets and on papyrus. It took centuries for these forms to be *accepted by the eye* and elevated to the rank of formal and semi-formal writing. Inscribing on a wax tablet with a metal stylus (a practice continuing into the Renaissance) presented difficulties. The stylus could not produce curves without breaking wax loose; so curves tended to flatten out or be replaced by straight lines. One of the most difficult letters to write on wax was the *S* (see Figure 10-1). In join-

Most of the minuscule forms were anticipated very early in the Roman period by scribbles on wax tablets and on papyrus. It took centuries for these forms to be *accepted by the eye* and elevated to the rank of formal and semi-formal writing. Inscribing on a wax tablet with a metal stylus (a practice continuing into the Renaissance) presented difficulties. The stylus could not produce curves without breaking wax loose; so curves tended to flatten out or be replaced by straight lines. One of the most difficult letters to write on wax was the *S* (see Figure 10-1). In join-

12/15, 40p4 max line length

Most of the minuscule forms were anticipated very early in the Roman period by scribbles on wax tablets and on papyrus. It took centuries for these forms to be *accepted by the eye* and elevated to the rank of formal and semi-formal writing. Inscribing on a wax tablet with a metal stylus (a practice continuing into the Renaissance) presented difficulties. The stylus could not produce curves without breaking wax loose; so curves tended to flatten out or be replaced by straight lines. One of the most difficult letters to write on wax was

13/16

Most of the minuscule forms were anticipated very early in the Roman period by scribbles on wax tablets and on papyrus. It took centuries for these forms to be *accepted by the eye* and elevated to the rank of formal and semi-formal writing. In-scribing on a wax tablet with a metal stylus (a practice continuing into the Renaissance) presented difficulties. The stylus could not produce curves without breaking wax loose; so curves tended to flatten out or be replaced by straight lines. One of

14/17

Most of the minuscule forms were anticipated very early in the Roman period by scribbles on wax tablets and on papyrus. It took centuries for these forms to be *accepted by the eye* and elevated to the rank of formal and semi-formal writing. Inscribing on a wax tablet with a metal stylus (a practice continuing into the Renaissance) presented difficulties. The stylus could not produce curves without breaking wax loose; so curves tended to flatten out or be re-

16/19

Most of the minuscule forms were anticipated very early in the Roman period by scribbles on wax tablets and on papyrus. It took centuries for these forms to be *accepted by the eye* and elevated to the rank of formal and semi-formal writing. Inscribing on a wax tablet with a metal stylus (a practice continuing into the Renais-sance) presented difficulties. The stylus could not produce curves

18/21

Most of the minuscule forms were anticipated very early in the Roman period by scribbles on wax tablets and on papy-rus. It took centuries for these forms to be *accepted by the eye* and elevated to the rank of formal and semi-formal writ-ing. Inscribing on a wax tablet with a metal stylus (a practice continuing into the Renaissance) presented difficulties. The

20/24

Most of the minuscule forms were anticipated very early in the Roman period by scribbles on wax tablets and on papyrus. It took centuries for these forms to be *accepted by the eye* and elevated to the rank of formal and semi-formal writing. Inscribing on a wax tablet with a metal stylus (a practice continuing into the Ren-

Sans Medium 24 Most of the minuscule forms were anticipated

30 Most of the minuscule forms were ant

36 Most of the minuscule forms w

42 Most of the minuscule for

48 Most of the minuscule f

54 Most of the minuscul

60 Most of the minus

Sans Medium Italic 24 *Most of the minuscule forms were anticipated ver*

30 *Most of the minuscule forms were antici*

36 *Most of the minuscule forms wer*

42 *Most of the minuscule forms*

48 *Most of the minuscule fo*

54 *Most of the minuscule*

60 *Most of the minusc*

Most of the minuscule forms were anticipat

Most of the minuscule forms were a

Most of the minuscule forms

Most of the minuscule for

Most of the minuscule

Most of the minusc

Most of the minus

Most of the minuscule forms were anticipated v

Most of the minuscule forms were anti

Most of the minuscule forms we

Most of the minuscule form

Most of the minuscule f

Most of the minuscul

Most of the minusc

24 **Most of the minuscule forms were antici**

30 **Most of the minuscule forms we**

36 **Most of the minuscule for**

42 **Most of the minuscule f**

48 **Most of the minuscu**

54 **Most of the minus**

60 **Most of the min**

24 ***Most of the minuscule forms were anticipat***

30 ***Most of the minuscule forms were a***

36 ***Most of the minuscule forms***

42 ***Most of the minuscule for***

48 ***Most of the minuscule***

54 ***Most of the minusc***

60 ***Most of the minus***

MOST MINUSCULE FORMS WERE ANTICIPATE

MOST MINUSCULE FORMS WERE ANTICIP

MOST MINUSCULE FORMS WERE ANT

MOST MINUSCULE FORMS WERE A

letterspacing normal

+0.05 em

+0.10 em

+0.15 em

letterspacing +0.02 em > horizontal scaling 105% >>	Most of the minuscule forms were anticipated very early in the Roman period by scribbles on wax tablets and on papyrus. It took centuries for	Most of the minuscule forms were anticipated very early in the Roman period by scribbles on wax tablets and on papyrus. It took centuries for
normal > normal >>	Most of the minuscule forms were anticipated very early in the Roman period by scribbles on wax tablets and on papyrus. It took centuries for these	Most of the minuscule forms were anticipated very early in the Roman period by scribbles on wax tablets and on papyrus. It took centuries for these
–0.02 em > 95% >>	Most of the minuscule forms were anticipated very early in the Roman period by scribbles on wax tablets and on papyrus. It took centuries for these forms to be	Most of the minuscule forms were anticipated very early in the Roman period by scribbles on wax tablets and on papyrus. It took centuries for these forms to be
–0.04 em > 90% >>	Most of the minuscule forms were anticipated very early in the Roman period by scribbles on wax tablets and on papyrus. It took centuries for these forms to be accepted	Most of the minuscule forms were anticipated very early in the Roman period by scribbles on wax tablets and on papyrus. It took centuries for these forms to be accepted

word spacing normal (0.2875 em)

Most of the Minuscule Forms Were Anticipate

0.250 em

Most of the Minuscule Forms Were Anticipate

0.200 em

Most of the Minuscule Forms Were Anticipated

0.167 em

Most of the Minuscule Forms Were Anticipated

word spacing normal (0.2875 em)	Most of the minuscule forms were anticipated very early in the Roman period by scribbles on wax tablets and on papyrus. It took centuries for these	*Most of the minuscule forms were anticipated very early in the Roman period by scribbles on wax tablets and on papyrus. It took centuries for these forms to be*
0.250 em	Most of the minuscule forms were anticipated very early in the Roman period by scribbles on wax tab-lets and on papyrus. It took centuries for these forms	*Most of the minuscule forms were anticipated very early in the Roman period by scribbles on wax tablets and on papyrus. It took centuries for these forms to be*
0.200 em	Most of the minuscule forms were anticipated very early in the Roman period by scribbles on wax tablets and on papyrus. It took centuries for these forms to	*Most of the minuscule forms were anticipated very early in the Roman period by scribbles on wax tablets and on papyrus. It took centuries for these forms to be accepted*
0.166 em	Most of the minuscule forms were anticipated very early in the Roman period by scribbles on wax tablets and on papyrus. It took centuries for these forms to be	*Most of the minuscule forms were anticipated very early in the Roman period by scribbles on wax tablets and on papyrus. It took centuries for these forms to be accepted*

10/13 Medium > 10/13 Medium Italic >>	Most of the minuscule forms were anticipated very early in the Roman period by scribbles on wax tablets and on papyrus. It took centuries for these forms to be accepted by the eye and elevated to the rank of formal and semi-formal writing. Inscrib-	*Most of the minuscule forms were anticipated very early in the Roman period by scribbles on wax tablets and on papyrus. It took centuries for these forms to be accepted by the eye and elevated to the rank of formal and semi-formal writing. Inscribing on a wax*

10/13 Semibold >
 10/13 Semibold Italic >>

Most of the minuscule forms were anticipated very early in the Roman period by scribbles on wax tablets and on papyrus. It took centuries for these forms to be accepted by the eye and elevated to the rank of formal and semi-formal

Most of the minuscule forms were anticipated very early in the Roman period by scribbles on wax tablets and on papyrus. It took centuries for these forms to be accepted by the eye and elevated to the rank of formal and semi-formal writing. Inscribing

10/13 Bold >
 10/13 Bold Italic >>

Most of the minuscule forms were anticipated very early in the Roman period by scribbles on wax tablets and on papyrus. It took centuries for these forms to be accepted by the eye and elevated to the rank of formal

Most of the minuscule forms were anticipated very early in the Roman period by scribbles on wax tablets and on papyrus. It took centuries for these forms to be accepted by the eye and elevated to the rank of formal and semi-formal

Semibold within Medium >
 Bold within Medium >>

Most of the minuscule forms were anticipated very early in the Roman period by scribbles on wax tablets and on **papyrus**. It took centuries for these forms to be accepted by the eye and elevated to the rank of formal and semi-formal writing. Inscrib-

Most of the minuscule forms were anticipated very early in the Roman period by scribbles on wax tablets and on **papyrus**. It took centuries for these forms to be accepted by the eye and elevated to the rank of formal and semi-formal writing. Inscrib-

Bold within Semibold >
 Figures within capitals >>

Most of the minuscule forms were anticipated very early in the Roman period by scribbles on wax tablets and on papyrus. It took centuries for these forms to be accepted by the eye and elevated to the rank of formal and semi-formal

MOST OF THE MINUSCULE FORMS WERE ANTICI-PATED VERY EARLY IN THE 48 ROMAN PERIOD BY SCRIBBLES ON WAX TABLETS AND ON PAPYRUS. IT TOOK $20,765 CENTURIES FOR THESE FORMS TO BE ACCEPTED BY THE EYE AND ELEVATED TO THE

10 pt. figures within 10 pt. text >
 9 pt. figures within 10 pt. text >>

Most of the minuscule forms were anticipated very early in the Roman period by 48 scribbles on wax tablets and on papyrus. It took centuries for these forms to be $20,765 accepted by the eye and elevated to the rank of formal and semi-formal writing

Most of the minuscule forms were anticipated very early in the Roman period by 48 scribbles on wax tablets and on papyrus. It took centuries for these forms to be $20,765 accepted by the eye and elevated to the rank of formal and semi-formal writing

7.25 pt. and 10 pt. Medium capitals >
 7.25 pt. Semibold capitals >>

MOST OF THE MINUSCULE forms were anticipated very early in the Roman period by ASCII scribbles on wax tablets and on papyrus. It took centuries for these forms to be ASCII accepted by the eye and elevated to the rank of formal and semi-formal writing. In-

MOST OF THE MINUSCULE forms were anticipated very early in the Roman period by ASCII scribbles on wax tablets and on papyrus. It took centuries for these forms to be ASCII accepted by the eye and elevated to the rank of formal and semi-formal writing. In-

4/5 Medium >
 4/5 Semibold >>

Most of the minuscule forms were anticipated very early in the Roman period by scribbles on wax tablets and on papyrus. It took centuries for these forms to be accepted by the eye and elevated to the rank of formal and semi-formal writing. Inscribing on a wax tablet with a metal stylus (a practice continuing into the Renaissance) presented difficulties. The stylus could not produce curves without breaking wax loose; so curves tended to flatten out or be replaced by straight lines. One of the most difficult letters to write on wax was the S (see Figure 10-1). In joining into S, the E, for instance, introduced a spur on the left side of S. This was retained, even after S was made a formal, edged-pen letter in the sixth century A.D. This long S remained in use in both handwriting and typography until well into the nineteenth century. Although it is a good letter, it had many ligatures, which required many compartments in the typecase. Typographers discarded it finally, for typesetting was easier without it. In handwriting, however, it would be a convenient letter, especially when a double s has to be written (see Figure 10-5). This double makes a pleasing design with an elegant counter, but today readers are confused by it, thinking it is an f, although the cross bar is missing. It was scribbling on papyrus, however, that produces the cursive rounding of angles. The tendency of the hand to produce flourishes, if not restrained by the eye, will result in ridiculous letterforms, such as those found among the commercial cursive majus-

Most of the minuscule forms were anticipated very early in the Roman period by scribbles on wax tablets and on papyrus. It took centuries for these forms to be accepted by the eye and elevated to the rank of formal and semi-formal writing. Inscribing on a wax tablet with a metal stylus (a practice continuing into the Renaissance) presented difficulties. The stylus could not produce curves without breaking wax loose; so curves tended to flatten out or be replaced by straight lines. One of the most difficult letters to write on wax was the S (see Figure 10-1). In joining into S, the E, for instance, introduced a spur on the left side of S. This was retained, even after S was made a formal, edged-pen letter in the sixth century A.D. This long S remained in use in both handwriting and typography until well into the nineteenth century. Although it is a good letter, it had many ligatures, which required many compartments in the typecase. Typographers discarded it finally, for typesetting was easier without it. In handwriting, however, it would be a convenient letter, especially when a double s has to be written (see Figure 10-5). This double makes a pleasing design with an elegant counter, but today readers are confused by it, thinking it is an f, although the cross bar is missing. It was scribbling on papyrus, however, that produces the cursive rounding of angles. The tendency of the hand to produce flourishes, if not restrained by the eye, will

5/6 Medium >
 5/6 Semibold >>

Most of the minuscule forms were anticipated very early in the Roman period by scribbles on wax tablets and on papyrus. It took centuries for these forms to be accepted by the eye and elevated to the rank of formal and semi-formal writing. Inscribing on a wax tablet with a metal stylus (a practice continuing into the Renaissance) presented difficulties. The stylus could not produce curves without breaking wax loose; so curves tended to flatten out or be replaced by straight lines. One of the most difficult letters to write on wax was the S (see Figure 10-1). In joining into S, the E, for instance, introduced a spur on the left side of S. This was retained, even after S was made a formal, edged-pen letter in the sixth century A.D. This long S remained in use in both handwriting and typography until well into the nineteenth century. Although it is a good letter, it had many ligatures, which required many compartments in the typecase. Typographers discarded it finally, for typesetting was easier without it. In handwriting,

Most of the minuscule forms were anticipated very early in the Roman period by scribbles on wax tablets and on papyrus. It took centuries for these forms to be accepted by the eye and elevated to the rank of formal and semi-formal writing. Inscribing on a wax tablet with a metal stylus (a practice continuing into the Renaissance) presented difficulties. The stylus could not produce curves without breaking wax loose; so curves tended to flatten out or be replaced by straight lines. One of the most difficult letters to write on wax was the S (see Figure 10-1). In joining into S, the E, for instance, introduced a spur on the left side of S. This was retained, even after S was made a formal, edged-pen letter in the sixth century A.D. This long S remained in use in both handwriting and typography until well into the nineteenth century. Although it is a good letter, it had many ligatures, which required many compartments in the typecase. Typographers discarded

6/7 Medium >
 6/7 Semibold >>

Most of the minuscule forms were anticipated very early in the Roman period by scribbles on wax tablets and on papyrus. It took centuries for these forms to be accepted by the eye and elevated to the rank of formal and semi-formal writing. Inscribing on a wax tablet with a metal stylus (a practice continuing into the Renaissance) presented difficulties. The stylus could not produce curves without breaking wax loose; so curves tended to flatten out or be replaced by straight lines. One of the most difficult letters to write on wax was the S (see Figure 10-1). In joining into S, the E, for instance, introduced a spur on the left side of S. This was retained, even after S was made a formal, edged-pen letter in the sixth century A.D. This long S remained in use in both hand-

Most of the minuscule forms were anticipated very early in the Roman period by scribbles on wax tablets and on papyrus. It took centuries for these forms to be accepted by the eye and elevated to the rank of formal and semi-formal writing. Inscribing on a wax tablet with a metal stylus (a practice continuing into the Renaissance) presented difficulties. The stylus could not produce curves without breaking wax loose; so curves tended to flatten out or be replaced by straight lines. One of the most difficult letters to write on wax was the S (see Figure 10-1). In joining into S, the E, for instance, introduced a spur on the left side of S. This was retained, even after S was made a formal, edged-pen letter in the sixth

STONE INFORMAL

ABCDEFGHIJKLMNOPQRSTUVWXYZ
abcdefghijklmnopqrstuvwxyz
fiflß æœ ÆŒ åèíöûñç ÅÈÍÖÛÑÇ
1234567890& .,:;'’“”- – —?!/)]}‹›«»
$¢£¥ƒ†‡*§¶%@#

ABCDEFGHIJKLMNOPQRSTUVWXYZ
abcdefghijklmnopqrstuvwxyz
fiflß æœ ÆŒ åèíöûñç ÅÈÍÖÛÑÇ
1234567890& .,:;'’“”- – —?!/)]}‹›«»
$¢£¥ƒ†‡*§¶%@#

ABCDEFGHIJKLMNOPQRSTUVWXYZ
abcdefghijklmnopqrstuvwxyz
fiflß æœ ÆŒ åèíöûñç ÅÈÍÖÛÑÇ
1234567890& .,:;'’“”- – —?!/)]}‹›«»
$¢£¥ƒ†‡*§¶%@#

Medium Italic

ABCDEFGHIJKLMNOPQRSTUVWXYZ
abcdefghijklmnopqrstuvwxyz
fiflß œœ ÆŒ åèíöûñç ÅÈÍÖÛÑÇ
1234567890& .,:;''""-–—?!/)]}‹›«»
$¢£¥ƒ†‡*§¶%@#

Semibold Italic

ABCDEFGHIJKLMNOPQRSTUVWXYZ
abcdefghijklmnopqrstuvwxyz
fiflß œœ ÆŒ åèíöûñç ÅÈÍÖÛÑÇ
1234567890& .,:;''""-–—?!/)]}‹›«»
$¢£¥ƒ†‡*§¶%@#

Bold Italic

ABCDEFGHIJKLMNOPQRSTUVWXYZ
abcdefghijklmnopqrstuvwxyz
fiflß œœ ÆŒ åèíöûñç ÅÈÍÖÛÑÇ
1234567890& .,:;''""-–—?!/)]}‹›«»
$¢£¥ƒ†‡*§¶%@#

Changes in letterforms were due to the dialectical opposition between formal (eye) tendencies and the informal, cursive (hand) tendencies (see Benson and Carey: *The Elements of Lettering*). The tendencies of the eye are conservative; the tendencies of the hand are innovative. Any particular alphabet system, such as Uncial, Carolingian, Roman, Italic, is a synthesis, a resolution, of the opposition between eye and hand. The eye, striving to be true to remembered designs, would

8/10

Changes in letterforms were due to the dialectical opposition between formal (eye) tendencies and the informal, cursive (hand) tendencies (see Benson and Carey: *The Elements of Lettering*). The tendencies of the eye are conservative; the tendencies of the hand are innovative. Any particular alphabet system, such as Uncial, Carolingian, Roman, Italic, is a synthesis, a resolution, of the opposition between eye and hand. The eye, striving to be true to remembered designs, would

8/11

Changes in letterforms were due to the dialectical opposition between formal (eye) tendencies and the informal, cursive (hand) tendencies (see Benson and Carey: *The Elements of Lettering*). The tendencies of the eye are conservative; the tendencies of the hand are innovative. Any particular alphabet system, such as Uncial, Carolingian, Roman, Italic, is a synthesis, a resolution, of the opposition between eye and hand. The eye, striving to be true to remembered designs, would

8/12

Changes in letterforms were due to the dialectical opposition between formal (eye) tendencies and the informal, cursive (hand) tendencies (see Benson and Carey: *The Elements of Lettering*). The tendencies of the eye are conservative; the tendencies of the hand are innovative. Any particular alphabet system, such as Uncial, Carolingian, Roman, Italic, is a synthesis, a resolution, of the opposition between eye and hand. The eye, striving to be true to remembered designs, would

Informal Medium

8/13

Changes in letterforms were due to the dialectical opposition between formal (eye) tendencies and the informal, cursive (hand) tendencies (see Benson and Carey: *The Elements of Lettering*). The tendencies of the eye are conservative; the tendencies of the hand are innovative. Any particular alphabet system, such as Uncial, Carolingian, Roman, Italic, is a synthesis, a resolution, of the opposition between eye and hand. The eye, striving to be true to remembered designs, would

8/14

Changes in letterforms were due to the dialectical opposition between formal (eye) tendencies and the informal, cursive (hand) tendencies (see Benson and Carey: *The Elements of Lettering*). The tendencies of the eye are conservative; the tendencies of the hand are innovative. Any particular alphabet system, such as Uncial, Carolingian, Roman, Italic, is a synthesis, a resolution, of the opposition between eye and hand. The eye, striving to be true to remembered designs, would

8/15

Changes in letterforms were due to the dialectical opposition between formal (eye) tendencies and the informal, cursive (hand) tendencies (see Benson and Carey: *The Elements of Lettering*). The tendencies of the eye are conservative; the tendencies of the hand are innovative. Any particular alphabet system, such as Uncial, Carolingian, Roman, Italic, is a synthesis, a resolution, of the opposition between eye and hand. The eye, striving to be true to remembered designs, would

Changes in letterforms were due to the dialectical opposition between formal (eye) tendencies and the informal, cursive (hand) tendencies (see Benson and Carey: *The Elements of Lettering*). The tendencies of the eye are conservative; the tendencies of the hand are innovative. Any particular alphabet system, such as Uncial, Carolingian, Roman, Italic, is a synthesis, a resolution, of the opposition between eye and hand.

9/11

Changes in letterforms were due to the dialectical opposition between formal (eye) tendencies and the informal, cursive (hand) tendencies (see Benson and Carey: *The Elements of Lettering*). The tendencies of the eye are conservative; the tendencies of the hand are innovative. Any particular alphabet system, such as Uncial, Carolingian, Roman, Italic, is a synthesis, a resolution, of the opposition between eye and hand.

9/12

Changes in letterforms were due to the dialectical opposition between formal (eye) tendencies and the informal, cursive (hand) tendencies (see Benson and Carey: *The Elements of Lettering*). The tendencies of the eye are conservative; the tendencies of the hand are innovative. Any particular alphabet system, such as Uncial, Carolingian, Roman, Italic, is a synthesis, a resolution, of the opposition between eye and hand.

9/13

Changes in letterforms were due to the dialectical opposition between formal (eye) tendencies and the informal, cursive (hand) tendencies (see Benson and Carey: *The Elements of Lettering*). The tendencies of the eye are conservative; the tendencies of the hand are innovative. Any particular alphabet system, such as Uncial, Carolingian, Roman, Italic, is a synthesis, a resolution, of the opposition between eye and hand.

9/14

Changes in letterforms were due to the dialectical opposition between formal (eye) tendencies and the informal, cursive (hand) tendencies (see Benson and Carey: *The Elements of Lettering*). The tendencies of the eye are conservative; the tendencies of the hand are innovative. Any particular alphabet system, such as Uncial, Carolingian, Roman, Italic, is a synthesis, a resolution, of the opposition between eye and hand.

9/15

Changes in letterforms were due to the dialectical opposition between formal (eye) tendencies and the informal, cursive (hand) tendencies (see Benson and Carey: *The Elements of Lettering*). The tendencies of the eye are conservative; the tendencies of the hand are innovative. Any particular alphabet system, such as Uncial, Carolingian, Roman, Italic, is a synthesis, a resolution, of the opposition between eye and hand.

Changes in letterforms were due to the dialecti-
cal opposition between formal (eye) tendencies
and the informal, cursive (hand) tendencies
(see Benson and Carey: *The Elements of Lettering*).
The tendencies of the eye are conservative; the
tendencies of the hand are innovative. Any par-
ticular alphabet system, such as Uncial, Carolin-
gian, Roman, Italic, is a synthesis, a resolution,

10/12
Changes in letterforms were due to the dialecti-
cal opposition between formal (eye) tendencies
and the informal, cursive (hand) tendencies
(see Benson and Carey: *The Elements of Lettering*).
The tendencies of the eye are conservative; the
tendencies of the hand are innovative. Any par-
ticular alphabet system, such as Uncial, Carolin-
gian, Roman, Italic, is a synthesis, a resolution,

10/13
Changes in letterforms were due to the dialecti-
cal opposition between formal (eye) tendencies
and the informal, cursive (hand) tendencies
(see Benson and Carey: *The Elements of Lettering*).
The tendencies of the eye are conservative; the
tendencies of the hand are innovative. Any par-
ticular alphabet system, such as Uncial, Carolin-
gian, Roman, Italic, is a synthesis, a resolution,

10/14
Changes in letterforms were due to the dialecti-
cal opposition between formal (eye) tendencies
and the informal, cursive (hand) tendencies
(see Benson and Carey: *The Elements of Lettering*).
The tendencies of the eye are conservative; the
tendencies of the hand are innovative. Any par-
ticular alphabet system, such as Uncial, Carolin-
gian, Roman, Italic, is a synthesis, a resolution,

10/15
Changes in letterforms were due to the dialecti-
cal opposition between formal (eye) tendencies
and the informal, cursive (hand) tendencies
(see Benson and Carey: *The Elements of Lettering*).
The tendencies of the eye are conservative; the
tendencies of the hand are innovative. Any par-
ticular alphabet system, such as Uncial, Carolin-
gian, Roman, Italic, is a synthesis, a resolution,

Changes in letterforms were due to the dialectical opposition
between formal (eye) tendencies and the informal, cursive (hand)
tendencies (see Benson and Carey: *The Elements of Lettering*). The ten-
dencies of the eye are conservative; the tendencies of the hand are
innovative. Any particular alphabet system, such as Uncial, Carolin-
gian, Roman, Italic, is a synthesis, a resolution, of the opposition
between eye and hand. The eye, striving to be true to remembered
designs, would keep to the guide lines, maintain angular construc-

11/13
Changes in letterforms were due to the dialectical opposition
between formal (eye) tendencies and the informal, cursive (hand)
tendencies (see Benson and Carey: *The Elements of Lettering*). The ten-
dencies of the eye are conservative; the tendencies of the hand are
innovative. Any particular alphabet system, such as Uncial, Carolin-
gian, Roman, Italic, is a synthesis, a resolution, of the opposition
between eye and hand. The eye, striving to be true to remembered
designs, would keep to the guide lines, maintain angular construc-

11/14
Changes in letterforms were due to the dialectical opposition
between formal (eye) tendencies and the informal, cursive (hand)
tendencies (see Benson and Carey: *The Elements of Lettering*). The ten-
dencies of the eye are conservative; the tendencies of the hand are
innovative. Any particular alphabet system, such as Uncial, Carolin-
gian, Roman, Italic, is a synthesis, a resolution, of the opposition
between eye and hand. The eye, striving to be true to remembered
designs, would keep to the guide lines, maintain angular construc-

11/15
Changes in letterforms were due to the dialectical opposition
between formal (eye) tendencies and the informal, cursive (hand)
tendencies (see Benson and Carey: *The Elements of Lettering*). The ten-
dencies of the eye are conservative; the tendencies of the hand are
innovative. Any particular alphabet system, such as Uncial, Carolin-
gian, Roman, Italic, is a synthesis, a resolution, of the opposition
between eye and hand. The eye, striving to be true to remembered
designs, would keep to the guide lines, maintain angular construc-

12/15, 40p4 max line length

Changes in letterforms were due to the dialectical opposition between formal (eye) tendencies and the informal, cursive (hand) tendencies (see Benson and Carey: *The Elements of Lettering*). The tendencies of the eye are conservative; the tendencies of the hand are innovative. Any particular alphabet system, such as Uncial, Carolingian, Roman, Italic, is a synthesis, a resolution, of the opposition between eye and hand. The eye, striving to be true to remembered designs, would keep to the guide lines,

13/16

Changes in letterforms were due to the dialectical opposition between formal (eye) tendencies and the informal, cursive (hand) tendencies (see Benson and Carey: *The Elements of Lettering*). The tendencies of the eye are conservative; the tendencies of the hand are innovative. Any particular alphabet system, such as Uncial, Carolingian, Roman, Italic, is a synthesis, a resolution, of the opposition between eye and hand. The eye, striving to be true to remembered designs

14/17

Changes in letterforms were due to the dialectical opposition between formal (eye) tendencies and the informal, cursive (hand) tendencies (see Benson and Carey: *The Elements of Lettering*). The tendencies of the eye are conservative; the tendencies of the hand are innovative. Any particular alphabet system, such as Uncial, Carolingian, Roman, Italic, is a synthesis, a resolution, of the opposition between eye and hand. The eye

16/19

Changes in letterforms were due to the dialectical opposition between formal (eye) tendencies and the informal, cursive (hand) tendencies (see Benson and Carey: *The Elements of Lettering*). The tendencies of the eye are conservative; the tendencies of the hand are innovative. Any particular alphabet system, such as Uncial, Carolingian, Roman, Italic, is a synthesis, a resolution,

18/21

Changes in letterforms were due to the dialectical opposition between formal (eye) tendencies and the informal, cursive (hand) tendencies (see Benson and Carey: *The Elements of Lettering*). The tendencies of the eye are conservative; the tendencies of the hand are innovative. Any particular alphabet system, such as Uncial, Carolingian

20/24

Changes in letterforms were due to the dialectical opposition between formal (eye) tendencies and the informal, cursive (hand) tendencies (see Benson and Carey: *The Elements of Lettering*). The tendencies of the eye are conservative; the tendencies of the hand are innovative. Any particular alphabet system,

Informal Medium

24 Changes in letterforms were due to the dial

30 Changes in letterforms were due to

36 Changes in letterforms were

42 Changes in letterforms w

48 Changes in letterform

54 Changes in letterfo

60 Changes in letter

Informal Medium Italic

24 *Changes in letterforms were due to the dialecti*

30 *Changes in letterforms were due to th*

36 *Changes in letterforms were du*

42 *Changes in letterforms wer*

48 *Changes in letterforms*

54 *Changes in letterfor*

60 *Changes in letterfo*

24 Changes in letterforms were due to the d

30 Changes in letterforms were due

36 Changes in letterforms wer

42 Changes in letterforms

48 Changes in letterfor

54 Changes in letterf

60 Changes in lette

24 *Changes in letterforms were due to the dia*

30 *Changes in letterforms were due t*

36 *Changes in letterforms were*

42 *Changes in letterforms*

48 *Changes in letterform*

54 *Changes in letterfo*

60 *Changes in letter*

Informal Bold

24 **Changes in letterforms were due to th**

30 **Changes in letterforms were d**

36 **Changes in letterforms w**

42 **Changes in letterform**

48 **Changes in letterfo**

54 **Changes in letter**

60 **Changes in lett**

Informal Bold Italic

24 ***Changes in letterforms were due to the d***

30 ***Changes in letterforms were due***

36 ***Changes in letterforms wer***

42 ***Changes in letterforms***

48 ***Changes in letterfor***

54 ***Changes in letterf***

60 ***Changes in lette***

letterspacing
normal

CHANGES IN LETTERFORMS WERE DUE TO

+0.05 em

CHANGES IN LETTERFORMS WERE DUE

+0.10 em

CHANGES IN LETTERFORMS WERE D

+0.15 em

CHANGES IN LETTERFORMS WER

letterspacing +0.02 em >
horizontal scaling 105% >>

Changes in letterforms were due to the dialectical opposition between formal (eye) tendencies and the informal, cursive (hand) tenden-

Changes in letterforms were due to the dialectical opposition between formal (eye) tendencies and the informal, cursive (hand) tenden-

normal >
normal >>

Changes in letterforms were due to the dialectical opposition between formal (eye) tendencies and the informal, cursive (hand) tendencies (see

Changes in letterforms were due to the dialectical opposition between formal (eye) tendencies and the informal, cursive (hand) tendencies (see

−0.02 em >
95% >>

Changes in letterforms were due to the dialectical opposition between formal (eye) tendencies and the informal, cursive (hand) tendencies (see Benson

Changes in letterforms were due to the dialectical opposition between formal (eye) tendencies and the informal, cursive (hand) tendencies (see Benson

−0.04 em >
90% >>

Changes in letterforms were due to the dialectical opposition between formal (eye) tendencies and the informal, cursive (hand) tendencies (see Benson and

Changes in letterforms were due to the dialectical opposition between formal (eye) tendencies and the informal, cursive (hand) tendencies (see Benson and

word spacing
normal (0.2875 em)

Changes in Letterforms Were Due to the Di

0.250 em

Changes in Letterforms Were Due to the Di

0.200 em

Changes in Letterforms Were Due to the Dia

0.167 em

Changes in Letterforms Were Due to the Dial

word spacing
normal (0.2875 em)

Changes in letterforms were due to the dialectical opposition between formal (eye) tendencies and the informal, cursive (hand) tendencies (see

Changes in letterforms were due to the dialectical opposition between formal (eye) tendencies and the informal, cursive (hand) tendencies (see Benson and

0.250 em

Changes in letterforms were due to the dialectical opposition between formal (eye) tendencies and the informal, cursive (hand) tendencies (see Ben-

Changes in letterforms were due to the dialectical opposition between formal (eye) tendencies and the informal, cursive (hand) tendencies (see Benson and

0.200 em

Changes in letterforms were due to the dialectical opposition between formal (eye) tendencies and the informal, cursive (hand) tendencies (see Ben-

Changes in letterforms were due to the dialectical opposition between formal (eye) tendencies and the informal, cursive (hand) tendencies (see Benson and

0.166 em

Changes in letterforms were due to the dialectical opposition between formal (eye) tendencies and the informal, cursive (hand) tendencies (see Ben-

Changes in letterforms were due to the dialectical opposition between formal (eye) tendencies and the informal, cursive (hand) tendencies (see Benson and

10/13 Medium >
10/13 Medium Italic >>

Changes in letterforms were due to the dialectical opposition between formal (eye) tendencies and the informal, cursive (hand) tendencies (see Benson and Carey: The Elements of Lettering). The tendencies of the eye are conservative; the

Changes in letterforms were due to the dialectical opposition between formal (eye) tendencies and the informal, cursive (hand) tendencies (see Benson and Carey: The Elements of Lettering). The tendencies of the eye are conservative; the tendencies of the hand

10/13 Semibold >
10/13 Semibold Italic >>

Changes in letterforms were due to the dialectical opposition between formal (eye) tendencies and the informal, cursive (hand) tendencies (see Benson and Carey: The Elements of Lettering). The tendencies of the eye are con-

Changes in letterforms were due to the dialectical opposition between formal (eye) tendencies and the informal, cursive (hand) tendencies (see Benson and Carey: The Elements of Lettering). The tendencies of the eye are conservative;

10/13 Bold >
10/13 Bold Italic >>

Changes in letterforms were due to the dialectical opposition between formal (eye) tendencies and the informal, cursive (hand) tendencies (see Benson and Carey: The Elements of Lettering). The tendencies

Changes in letterforms were due to the dialectical opposition between formal (eye) tendencies and the informal, cursive (hand) tendencies (see Benson and Carey: The Elements of Lettering). The tendencies of the eye are con-

Semibold within Medium >
Bold within Medium >>

Changes in letterforms were due to the dialectical opposition between formal (eye) tendencies and the **informal**, cursive (hand) tendencies (see Benson and Carey: The Elements of Lettering). The tendencies of the eye are conservative; the

Changes in letterforms were due to the dialectical opposition between formal (eye) tendencies and the **informal**, cursive (hand) tendencies (see Benson and Carey: The Elements of Lettering). The tendencies of the eye are conservative;

Bold within Semibold >
Figures within capitals >>

Changes in letterforms were due to the dialectical opposition between formal (eye) tendencies and the informal, cursive (hand) tendencies (see Benson and Carey: The Elements of Lettering). The tendencies of the eye are con-

CHANGES IN LETTERFORMS WERE DUE TO THE DIALECTICAL OPPOSITION 48 BETWEEN FORMAL TENDENCIES AND THE INFORMAL, CURSIVE HAND $20,765 TENDENCIES SEE BENSON AND CAREY: THE ELEMENTS OF LETTERING.

10 pt. figures within 10 pt. text >
9 pt. figures within 10 pt. text >>

Changes in letterforms were due to the dialectical opposition between formal 48 tendencies and the informal, cursive hand tendencies see Benson and $20,765 carey: The Elements of Lettering. The tendencies of the eye are conservative;

Changes in letterforms were due to the dialectical opposition between formal 48 tendencies and the informal, cursive hand tendencies see Benson and $20,765 carey: The Elements of Lettering. The tendencies of the eye are conservative; the

7.25 pt. and 10 pt. Medium capitals >
7.25 pt. Semibold capitals >>

CHANGES IN LETTERFORMS were due to the dialectical opposition between formal ASCII tendencies and the informal, cursive (hand) tendencies (see Benson and ASCII Carey: The Elements of Lettering). The tendencies of the eye are conservative; the

CHANGES IN LETTERFORMS were due to the dialectical opposition between formal ASCII tendencies and the informal, cursive (hand) tendencies (see Benson and ASCII Carey: The Elements of Lettering). The tendencies of the eye are conservative;

4/5 Medium >
4/5 Semibold >>

Changes in letterforms were due to the dialectical opposition between formal (eye) tendencies and the informal, cursive (hand) tendencies (see Benson and Carey: *The Elements of Lettering*). The tendencies of the eye are conservative; the tendencies of the hand are innovative. Any particular alphabet system, such as Uncial, Carolingian, Roman, Italic, is a synthesis, a resolution, of the opposition between eye and hand. The eye, striving to be true to remembered designs, would keep to the guide lines, maintain angular constructions, and preserve vertically and horizontally the order and direction of strokes. The hand, however, would occasionally omit parts of letter, push extruders (ascenders and descender) through guide lines, round angles, tilt axes, add flourishes, and even (though rarely) change order and direction of stroke. Also the hand would avoid pen-lifts. The A, for instance, was written with three pulled strokes, the cross bar being the second stroke (Figure 5-1). In 2, the Rustic capital alphabet, the hand has omitted the cross bar and has produced an extruder at the top. In the Uncial, 3, the eye has demanded the return of the cross bar, but the hurrying hand prefers to keep the hand on the paper and avoid a pen-lift; so it cuts across lots to the right-hand diagonal. In 4, the ninth-century Carolingian, the hand has rounded the angle between the first diagonal and the cross bar. In 5, a tenth-century, late Carolingian, the eye has

Changes in letterforms were due to the dialectical opposition between formal (eye) tendencies and the informal, cursive (hand) tendencies (see Benson and Carey: *The Elements of Lettering*). The tendencies of the eye are conservative; the tendencies of the hand are innovative. Any particular alphabet system, such as Uncial, Carolingian, Roman, Italic, is a synthesis, a resolution, of the opposition between eye and hand. The eye, striving to be true to remembered designs, would keep to the guide lines, maintain angular constructions, and preserve vertically and horizontally the order and direction of strokes. The hand, however, would occasionally omit parts of letter, push extruders (ascenders and descender) through guide lines, round angles, tilt axes, add flourishes, and even (though rarely) change order and direction of stroke. Also the hand would avoid pen-lifts. The A, for instance, was written with three pulled strokes, the cross bar being the second stroke (Figure 5-1). In 2, the Rustic capital alphabet, the hand has omitted the cross bar and has produced an extruder at the top. In the Uncial, 3, the eye has demanded the return of the cross bar, but the hurrying hand prefers to keep the hand on the paper and avoid a pen-lift; so it cuts across lots to the right-hand diagonal. In 4, the ninth-century Carolingian, the hand has rounded the angle*

5/6 Medium >
5/6 Semibold >>

Changes in letterforms were due to the dialectical opposition between formal (eye) tendencies and the informal, cursive (hand) tendencies (see Benson and Carey: *The Elements of Lettering*). The tendencies of the eye are conservative; the tendencies of the hand are innovative. Any particular alphabet system, such as Uncial, Carolingian, Roman, Italic, is a synthesis, a resolution, of the opposition between eye and hand. The eye, striving to be true to remembered designs, would keep to the guide lines, maintain angular constructions, and preserve vertically and horizontally the order and direction of strokes. The hand, however, would occasionally omit parts of letter, push extruders (ascenders and descender) through guide lines, round angles, tilt axes, add flourishes, and even (though rarely) change order and direction of stroke. Also the hand would avoid pen-lifts. The A, for instance, was written with three pulled strokes, the cross bar being the second

Changes in letterforms were due to the dialectical opposition between formal (eye) tendencies and the informal, cursive (hand) tendencies (see Benson and Carey: *The Elements of Lettering*). The tendencies of the eye are conservative; the tendencies of the hand are innovative. Any particular alphabet system, such as Uncial, Carolingian, Roman, Italic, is a synthesis, a resolution, of the opposition between eye and hand. The eye, striving to be true to remembered designs, would keep to the guide lines, maintain angular constructions, and preserve vertically and horizontally the order and direction of strokes. The hand, however, would occasionally omit parts of letter, push extruders (ascenders and descender) through guide lines, round angles, tilt axes, add flourishes, and even (though rarely) change order and direction of stroke. Also the hand would avoid pen-lifts. The A, for instance, was written*

6/7 Medium >
6/7 Semibold >>

Changes in letterforms were due to the dialectical opposition between formal (eye) tendencies and the informal, cursive (hand) tendencies (see Benson and Carey: *The Elements of Lettering*). The tendencies of the eye are conservative; the tendencies of the hand are innovative. Any particular alphabet system, such as Uncial, Carolingian, Roman, Italic, is a synthesis, a resolution, of the opposition between eye and hand. The eye, striving to be true to remembered designs, would keep to the guide lines, maintain angular constructions, and preserve vertically and horizontally the order and direction of strokes. The hand, however, would occasionally omit parts of letter, push extruders (ascenders and descender) through guide

Changes in letterforms were due to the dialectical opposition between formal (eye) tendencies and the informal, cursive (hand) tendencies (see Benson and Carey: *The Elements of Lettering*). The tendencies of the eye are conservative; the tendencies of the hand are innovative. Any particular alphabet system, such as Uncial, Carolingian, Roman, Italic, is a synthesis, a resolution, of the opposition between eye and hand. The eye, striving to be true to remembered designs, would keep to the guide lines, maintain angular constructions, and preserve vertically and horizontally the order and direction of strokes. The hand, however, would occasionally omit parts of letter, push extruders*

		Stone Serif	Stone Sans
Medium	6	Grâce à leurs écrits nous connaissons donc leur Histoire «événementielle» comme	Grâce à leurs écrits nous connaissons donc leur Histoire «événementielle» comme on d
	8	Grâce à leurs écrits nous connaissons donc leur Histoire «évén	Grâce à leurs écrits nous connaissons donc leur Histoire «événem
	10	Grâce à leurs écrits nous connaissons donc leur Hi	Grâce à leurs écrits nous connaissons donc leur Histoi
	12	Grâce à leurs écrits nous connaissons don	Grâce à leurs écrits nous connaissons donc le
	14	Grâce à leurs écrits nous connaisson	Grâce à leurs écrits nous connaissons l
	18	Grâce à leurs écrits nous con	Grâce à leurs écrits nous conn
	24	Grâce à leurs écrits n	Grâce à leurs écrits no
Medium Italic	6	*Grâce à leurs écrits nous connaissons donc leur Histoire «événementielle» comme on dit*	*Grâce à leurs écrits nous connaissons donc leur Histoire «événementielle» comme on dit à*
	8	*Grâce à leurs écrits nous connaissons donc leur Histoire «événemen*	*Grâce à leurs écrits nous connaissons donc leur Histoire «événement*
	10	*Grâce à leurs écrits nous connaissons donc leur Histoir*	*Grâce à leurs écrits nous connaissons donc leur Histoire*
	12	*Grâce à leurs écrits nous connaissons donc le*	*Grâce à leurs écrits nous connaissons donc leu*
	14	*Grâce à leurs écrits nous connaissons le*	*Grâce à leurs écrits nous connaissons le*
	18	*Grâce à leurs écrits nous conna*	*Grâce à leurs écrits nous conna*
	24	*Grâce à leurs écrits nou*	*Grâce à leurs écrits nou*
Semibold	6	Grâce à leurs écrits nous connaissons donc leur Histoire «événementielle» com	Grâce à leurs écrits nous connaissons donc leur Histoire «événementielle» comme
	8	Grâce à leurs écrits nous connaissons donc leur Histoire «é	Grâce à leurs écrits nous connaissons donc leur Histoire «évén
	10	Grâce à leurs écrits nous connaissons donc leur	Grâce à leurs écrits nous connaissons donc leur His
	12	Grâce à leurs écrits nous connaissons do	Grâce à leurs écrits nous connaissons don
	14	Grâce à leurs écrits nous connaisso	Grâce à leurs écrits nous connaisson
	18	Grâce à leurs écrits nous co	Grâce à leurs écrits nous con
	24	Grâce à leurs écrits n	Grâce à leurs écrits n
Semibold Italic	6	*Grâce à leurs écrits nous connaissons donc leur Histoire «événementielle» comm*	*Grâce à leurs écrits nous connaissons donc leur Histoire «événementielle» comme on dit*
	8	*Grâce à leurs écrits nous connaissons donc leur Histoire «évé*	*Grâce à leurs écrits nous connaissons donc leur Histoire «événeme*
	10	*Grâce à leurs écrits nous connaissons donc leur H*	*Grâce à leurs écrits nous connaissons donc leur Histoir*
	12	*Grâce à leurs écrits nous connaissons do*	*Grâce à leurs écrits nous connaissons donc le*
	14	*Grâce à leurs écrits nous connaisso*	*Grâce à leurs écrits nous connaissons l*
	18	*Grâce à leurs écrits nous co*	*Grâce à leurs écrits nous conn*
	24	*Grâce à leurs écrits n*	*Grâce à leurs écrits no*
Bold	6	Grâce à leurs écrits nous connaissons donc leur Histoire «événementiel	Grâce à leurs écrits nous connaissons donc leur Histoire «événementielle» c
	8	Grâce à leurs écrits nous connaissons donc leur Histoi	Grâce à leurs écrits nous connaissons donc leur Histoire «
	10	Grâce à leurs écrits nous connaissons donc l	Grâce à leurs écrits nous connaissons donc leu
	12	Grâce à leurs écrits nous connaisson	Grâce à leurs écrits nous connaissons d
	14	Grâce à leurs écrits nous conna	Grâce à leurs écrits nous connais
	18	Grâce à leurs écrits nous	Grâce à leurs écrits nous c
	24	Grâce à leurs écrit	Grâce à leurs écrits,
Bold Italic	6	*Grâce à leurs écrits nous connaissons donc leur Histoire «événementielle*	*Grâce à leurs écrits nous connaissons donc leur Histoire «événementielle» comme*
	8	*Grâce à leurs écrits nous connaissons donc leur Histoir*	*Grâce à leurs écrits nous connaissons donc leur Histoire «évén*
	10	*Grâce à leurs écrits nous connaissons donc l*	*Grâce à leurs écrits nous connaissons donc leur Hi*
	12	*Grâce à leurs écrits nous connaisson*	*Grâce à leurs écrits nous connaissons don*
	14	*Grâce à leurs écrits nous conna*	*Grâce à leurs écrits nous connaisson*
	18	*Grâce à leurs écrits nous*	*Grâce à leurs écrits nous co*
	24	*Grâce à leurs écrit*	*Grâce à leurs écrits n*

Grâce à leurs écrits nous connaissons donc leur Histoire « événementielle » comme
Grâce à leurs écrits nous connaissons donc leur Histoire « évén
Grâce à leurs écrits nous connaissons donc leur Hi
Grâce à leurs écrits nous connaissons don
Grâce à leurs écrits nous connaisson
Grâce à leurs écrits nous con
Grâce à leurs écrits n

Grâce à leurs écrits nous connaissons donc leur Histoire « événementielle » comme on dit
Grâce à leurs écrits nous connaissons donc leur Histoire « événeme
Grâce à leurs écrits nous connaissons donc leur Histoir
Grâce à leurs écrits nous connaissons donc le
Grâce à leurs écrits nous connaissons l
Grâce à leurs écrits nous conn
Grâce à leurs écrits nou

Grâce à leurs écrits nous connaissons donc leur Histoire « événementielle » co
Grâce à leurs écrits nous connaissons donc leur Histoire « é
Grâce à leurs écrits nous connaissons donc leur
Grâce à leurs écrits nous connaissons d
Grâce à leurs écrits nous connaiss
Grâce à leurs écrits nous c
Grâce à leurs écrits,

Grâce à leurs écrits nous connaissons donc leur Histoire « événementielle » comm
Grâce à leurs écrits nous connaissons donc leur Histoire « évé
Grâce à leurs écrits nous connaissons donc leur H
Grâce à leurs écrits nous connaissons do
Grâce à leurs écrits nous connaisso
Grâce à leurs écrits nous co
Grâce à leurs écrits n

Grâce à leurs écrits nous connaissons donc leur Histoire « événementiel
Grâce à leurs écrits nous connaissons donc leur Histoi
Grâce à leurs écrits nous connaissons donc l
Grâce à leurs écrits nous connaisson
Grâce à leurs écrits nous conna
Grâce à leurs écrits nous
Grâce à leurs écrit

Grâce à leurs écrits nous connaissons donc leur Histoire « événementielle » co
Grâce à leurs écrits nous connaissons donc leur Histoire «
Grâce à leurs écrits nous connaissons donc leur
Grâce à leurs écrits nous connaissons d
Grâce à leurs écrits nous connaiss
Grâce à leurs écrits nous c
Grâce à leurs écrits,

verbsgohum
verbsgohum
verbsgohu
verbsgohuma
verbsgohum
verbsgohur
verbsgohum
verbsgohum
verbsgohu

Serif Medium / Sans Medium / Informal Medium / Serif Medium Italic /

Künst Künst Künst Künst Künst Künst *Künst* Künst

Künst Künst Künst Künst *Künst* Künst

/ Informal Bold Italic **Künst Künst** Künst Künst *Künst* Künst

/ Sans Bold Italic **Künst Künst** **Künst Künst** *Künst Künst*

/ Serif Bold Italic **Künst Künst** **Künst Künst** **Künst Künst**

/ Informal Bold **Künst Künst** **Künst Künst** **Künst Künst** **Künst Künst**

/ Sans Bold **Künst Künst** **Künst Künst** **Künst Künst** **Künst Künst**

/ Serif Bold **Künst Künst** **Künst Künst** **Künst Künst** **Künst Künst**

/ Informal Semibold Italic **Künst** *Künst* **Künst** *Künst* **Künst** *Künst* **Künst** *Künst*

/ Sans Semibold Italic **Künst** *Künst* **Künst** *Künst* **Künst** *Künst* **Künst** *Künst*

/ Serif Semibold Italic **Künst** *Künst* **Künst** *Künst* **Künst** *Künst* **Künst** *Künst*

/ Informal Semibold **Künst** Künst **Künst** Künst **Künst** Künst **Künst** Künst

/ Sans Semibold **Künst** Künst **Künst** Künst **Künst** Künst **Künst** Künst

/ Serif Semibold **Künst** Künst **Künst** Künst **Künst** Künst **Künst** Künst

/ Informal Medium Italic **Künst** *Künst* **Künst** *Künst* **Künst** *Künst* **Künst** *Künst*

/ Sans Medium Italic **Künst** *Künst* **Künst** *Künst* **Künst** *Künst* **Künst** *Künst*

/ Serif Medium Italic **Künst** *Künst* **Künst** *Künst* **Künst** *Künst* **Künst** *Künst*

/ Informal Medium **Künst** Künst **Künst** Künst **Künst** Künst **Künst** Künst

/ Sans Medium **Künst** Künst **Künst** Künst **Künst** Künst **Künst** Künst

/ Serif Medium **Künst** Künst **Künst** Künst **Künst** Künst **Künst** Künst

Informal Bold Italic / Sans Bold Italic / Serif Bold Italic / Informal Bold /

Sans Medium Italic	Informal Medium Italic	Serif Semibold	Sans Semibold	Informal Semibold
Künst Künst	*Künst* Künst	**Künst** Künst	**Künst** Künst	**Künst** Künst
Künst Künst	*Künst* Künst	**Künst** Künst	**Künst** Künst	**Künst** Künst
Künst Künst	*Künst* Künst	**Künst** Künst	**Künst** Künst	**Künst** Künst
Künst Künst	*Künst Künst*	**Künst** *Künst*	**Künst** *Künst*	**Künst** *Künst*
Künst Künst	*Künst Künst*	**Künst** *Künst*	**Künst** *Künst*	**Künst** *Künst*
	Künst Künst	**Künst** *Künst*	**Künst** *Künst*	**Künst** *Künst*
Künst Künst		Künst Künst	**Künst Künst**	**Künst Künst**
Künst Künst	**Künst Künst**		**Künst Künst**	**Künst Künst**
Künst *Künst*	**Künst** *Künst*	**Künst Künst**		**Künst Künst**
Künst *Künst*	**Künst** *Künst*	**Künst Künst**	*Künst Künst*	
Künst *Künst*	**Künst** *Künst*	**Künst Künst**	*Künst Künst*	*Künst Künst*
Künst Künst	**Künst** Künst	*Künst* Künst	*Künst* Künst	*Künst* Künst
Künst Künst	**Künst** Künst	*Künst* Künst	*Künst* Künst	*Künst* Künst
Künst Künst	**Künst** Künst	*Künst* Künst	*Künst* Künst	*Künst* Künst
Künst *Künst*	**Künst** *Künst*	*Künst* *Künst*	*Künst* *Künst*	*Künst Künst*
Künst *Künst*	**Künst** *Künst*	*Künst* *Künst*	*Künst* *Künst*	*Künst Künst*
Künst *Künst*	**Künst** *Künst*	*Künst* *Künst*	*Künst* *Künst*	*Künst Künst*
Künst Künst	**Künst** Künst	*Künst* Künst	*Künst* Künst	*Künst* Künst
Künst Künst	**Künst** Künst	*Künst* Künst	*Künst* Künst	*Künst* Künst
Künst Künst	**Künst** Künst	*Künst* Künst	*Künst* Künst	*Künst* Künst

Type Specifications

The following is a key for the type specifications:

Text, 7/8.5 Sans Medium, 21p6, all capitals, letterspaced +0.33 em.

Text is an identifier for locating the body of type being considered.
7/8.8 is type size / leading. 7 is type size in points; 8.5 is leading (baseline to baseline line distance) in points.
21p6 is line length in picas and points; 21 picas 6 points.
letterspaced +0.33 em is a space equal to 33% of the point size of the type added between each pair of characters. The same convention for measurement is used to indicate word spacing.

Travel Guide, p.23
Text, 7/8 Sans Medium, 21p6.
City name, 10 pt. Sans Bold, all capitals.
Page number, 10 pt. Sans Medium.
City sections, 9 pt. Serif Semibold, all capitals, letterspaced +0.10 em.
Tour times and notes, 7 pt. Sans Medium Italic.
Points of interest, 7/8 Sans Bold.
Map locations, 7/8 Informal Bold.
Special points of interest, 7/8 Sans Semibold.
Table heading and "max" columns, 7/12 Sans Semibold.
Other tabular matter, 7/12 Sans Medium.
Map:
Index, 5/5 Sans Medium.
Locations, 5/5 Informal Bold.
Districts, 6 pt. Serif Semibold, all capitals, letterspaced +0.33 em.
Streets, 5 pt. Sans Medium.
Major buildings, 4/4.5 Sans Bold, all capitals, letterspaced +0.10 em.
Other important locations, 5 pt. Sans Semibold.
Numbered places of interest, 4 pt. Sans Medium.
River, 5 pt. Serif Medium Italic.
Road destinations at right-hand edge, 4/4 Sans Medium Italic.
Minor places, 4/4 Sans Medium Italic.
Symbols for post office, church, information, hospital, various sizes of the Carta typeface.
P for "Parking," 4 pt. Informal Bold.
Map coordinate divisions, 8 pt. Informal Bold.

Dictionary, p.24
Text, 6/6.5 Serif Medium with Italic, 8p11, justified.
Main entries, 5 pt. Sans Bold, "exdented" 4 pts.
Definition numbers and letters, 6 pt. Sans Semibold.
Word endings and variations, 6 pt. Sans Bold.
Pronunciations, 6 pt. Stone phonetic characters (not yet commercially available as of December 1990).
Page numbers, 6 pt. Serif Medium.
Guide words at top of page, 10 pt. Sans Bold.

Programming Manual, p.25
Text, 9/12 Serif Medium with Italic, 21p, flush left.
PostScript operators, 9/12 Serif Semibold.
Program listings, 9/12 Informal Medium and Semibold.
Section heading, 9 pt. Sans Bold.
Page number and footer, 7 pt. Sans Medium.

Periodic Table, pp.26–27
Element symbols, 24 pt. Sans Bold.
Atomic weight, electron configuration, and oxidation states, 7/10 Serif Medium.
Atomic numbers, 7 pt. Serif Bold.
Orbit names, 7 pt. Serif Medium.
"Lanthanides and actinides," 7 pt. Sans Bold.
"Transition," 10 pt. Sans Medium, Semibold, and Bold.
Period designations (for example, 1a), 10 pt. Sans Bold.

Body & Soul, p.29
Title, custom lettering by Sumner Stone.
Subtitle, 35.7 pt. Serif Semibold, letterspaced +0.12 em.
Authors, 28.75 pt. Serif Semibold, letterspaced +0.08 em.

Ten Philosophers, p.30
Title page:
Title, 24/32 Sans Semibold.
Subtitle, 12/22 Serif Medium Italic.
Publisher, 8 pt. Serif Medium Italic.
Chapter-opening page :
(approximate specs of reduced version)
Text, 6/8 Serif Medium, 14p, justified.
Author, 12 pt. Sans Semibold.
Title, 12/20 Serif Medium Italic.
Page number, 6 pt. Serif Medium Italic.

Photography Book, p.31
Text, 10/16 Sans Medium, 36p, flush left.
Marginal notes and caption, 7/9 Sans Medium and Italic, 8p7, flush left.
Page number and footer, 7 pt. Sans Semibold, all capitals, letterspaced +0.30 em.

China Book, pp.32–33
Chapter-opening spread:
Text, 9.5/12.5 Serif Medium, 26p6, justified.
Quotation, 8.5/11 Serif Medium, justified, indented 4p.
Chapter number, 40 pt. Serif Medium.
Chapter title, 20/24 Serif Semibold.
Section headings and running heads, 10.5 pt. Serif Medium Italic, horizontally scaled 105%.
Section subheadings, 7.25 pt. Serif Semibold, letterspaced +0.05 em.
Footnotes, 6/9 Serif Medium.
Contents page:
Chapter titles, 9.5 pt. Serif Medium.
Section headings, 9.5 pt. Serif Medium Italic, horizontally scaled 105%.
Section subheadings, 6.5/12 Serif Medium, all capitals, letterspaced +0.05 em.
Major division title, 11 pt. Serif Semibold.

Shakespeare, p.34
Text, 8/11 Serif Medium.
Players, 7 pt. Sans Semibold, all capitals, letterspaced +0.05 em.
Line numbers, 6 pt. Sans Medium.
Act and scene, 8 pt. Sans Semibold.

Children's Book, p.35
Text, 24/30 Informal Medium.
Page number, 12 pt. Informal Medium.

Newsletter, p.37
Text, 9/11 Serif Medium, 14p4, flush left, paragraph indent 9 pts.
Headlines, 21/23 Serif Semibold.
Pull quote, 9/22 Sans Bold.
Caption, 9/11 Sans Bold.
Masthead, 48 pt. Informal Semibold Italic.
Submasthead, 9 pt. Sans Bold.

(continued on next page)

Newspaper, pp.38–39
Text, 8.25/10 Serif Medium, 13p6, flush left.
Captions, 8.25/10 Sans Medium Italic.
Large headlines, 30 pt. Sans Bold, letterspacing –0.02 em.
Small headline, 20/20 Sans Bold.
Subheads, 12/13 Sans Medium.
By-lines, 12 pt. Sans Semibold.
By-line subtitles, 8.25 pt. Sans Medium.
Pull quote, 12/13.Serif Semibold Italic.
Internal story subheads, 8.25 pt. Serif Semibold.
Masthead, 84 pt. Serif Medium, letterspaced +0.03 em.
Masthead subhead, 18 pt. Serif Medium Italic, letterspaced –0.02 em.
Date, 10 pt. Serif Medium.
Volume, number, etc., 8.25/12.25 Serif Medium.
"Inside," 18 pt. Serif Bold Italic.
Index page numbers, 8.25 pt. Sans Semibold.
Inside listings, 8.25/10 Sans Medium.

Annual Report, p.40
Text and tables, 8/12 Sans Medium and Italic, 13p8, flush left, paragraph indent 8 pts.
Headings, 8/12 Sans Semibold Italic.
Arrowhead, 8 pt. Zapf Dingbat typeface.
Page number, 8 pt. Sans Semibold Italic.

Annual Report, p.41
Text, 9/12 Serif Medium.
Table numbers, 8.5/12 Serif Medium and Semibold.
Table headings, 7 pt. Serif Semibold, all capitals, letterspaced +0.10 em.
Footnote, 6.5 pt. Serif Medium.

Computer Display, p.43
(72 dots per inch)
Top screen:
Text, 14/17 Informal Medium.
Headline, 72 pt. Sans Bold.
Subhead, 27 pt. Serif Semibold.
Instructions, 14 pt. Informal Medium Italic.
Bottom screen:
Large type, 24 pt. Serif Medium and Bold.
Small type, 14 pt. Informal Medium.

Aquarium Signage, pp.44–45
Large sign, 80/86 Sans Semibold.
The other signs are reduced from actual sizes.

Puppet Logo, p.47–49
Letter and business card:
Text, 10/15 Informal Medium and Semibold.
Letterhead, personalization, and business card information, 9/11 Sans Medium and Bold.
Travel expense form:
Text, 8/15 Sans Medium.
Title, 18 pt. Sans Semibold.
Phone book ad:
Text, 10/13.5 Sans Medium, bullets 8 pt.
Headline and phone number, 14/15 Sans Semibold.
Name and address, 10/14.5 Sans Medium and Bold.
Invitation:
Text, 12/21 Informal Medium Italic.
Headline, 21 pt. Sans Bold.

Logos, p.50–51
CED: 36.5 pt. Sans Medium.
Astor Place Playhouse:
Name, 18 pt. Serif Medium Italic.
Eyes and nose, 14.4 pt. Sans Bold.
Asterisk, 480 pt. Sans Medium.
Rosen & Sons: 24 pt. Serif Medium.
ArtForum: 56.5/35.8 Sans Bold Italic.
K+K: 78.7 pt. Serif Medium.
M&N: 100.6 pt. Serif Medium.

Han Feng: 15.25 pt. Sans Semibold and 6.1 pt. Serif Semibold.
B (bird): 238.4 pt. Informal Semibold.
Jam Label:
"Aunt Joyce," 18.2 pt. Informal Semibold.
Other text,18.25 pt., 9.1 pt., 5.3/6.8 pt. Serif Medium Italic.
Cartografix: 36 pt. Sans Medium.

Menu, p.53
Dishes, 10/16 Sans Bold.
Descriptions and prices, 9/16 Serif Medium Italic.
Categories, 10 pt. Serif Medium, all capitals, letterspaced +0.30 em.

Summer Program, p.54
Text, 7/10 Serif Medium, 9p10, flush left.
Headline, 28.5/36.5 Sans Bold.
Subhead in top panel, 12 pt. Serif Medium.
Headings in bottom panel, 10 pt. Serif Medium.
"Yale," 24 pt. Serif Semibold.
Slope, 15 degrees.

Grand Strategy, p.55
Headline, 61.5/66.75 Sans Bold.
Text, 10.9/12.4 Sans Medium.
Slope, 45 degrees.

Sand Hill Road, p.56
Text, 10/12 Serif Medium, flush left.
Headline, 36/36 Serif Semibold, letterspaced –0.03 em.

European AutoCare, p.57
Text, 14/20 Sans Semibold and Italic.
Headline, 36 pt. Sans Bold.

History of Typography, p.58
Headline, 11.5 pt. Serif Semibold, letterspaced +0.09 em.
Subhead, 6 pt. Sans Medium.
List of names, 6/14 Sans Medium.

Japan, p.59
Headline, 184 pt. Sans Bold.
Subhead, 28.8 pt. Serif Semibold.
"Seattle . . . ," 10/10 Sans Bold.
Date, 5 pt. Sans Bold.
Location and phone, 5/7 Sans Medium.
Text and schedule, 5/6 Sans Medium and Italic.

Résumé, p.61
Text, 9.5/12 Serif Medium, Italic, and Semibold.
Name, 24 pt. Serif Medium Italic.

Graduation Party, p.62
Fine print, 5/6.5 Serif Medium and Bold, 31p6, justified.
Headline, 21/28 Serif Medium.
Information, 10/14 Serif Medium.

Blackout Party, p.63
Text, 9/12 Informal Medium, centered.
Headline, 14 pt. Informal Semibold.

Wedding Invitation, p.63
11/26 Serif Medium Italic, centered.

D Composition, p.64
8/14 Informal Medium, 5p6, flush left.

m Composition, p.65
10.8/24.3 Serif Medium Italic.

N Composition, p.65
5.5/11.5 Informal Medium Italic, 5p2, flush left.

Credits

Thoughts on Stone

Caslon Sans Serif, p.12
First showing of a sans serif typeface, from a specimen produced by the Caslon foundry, 1816.

Univers "U" Composition, p.12
Designed in 1960 by Bruno Pfäffli to show the twenty-one variations of Adrian Frutiger's Univers type family.

Punchcutting Photo, p.14
The young Matthew Carter cutting a punch. From the cover of *The New Mechanick Exercises*, Part Thirteen (Winter 1959), Surrey Fine Art Press Ltd, Redhill and London.

VIP Phototypesetting Grid, p.15
Courtesy of Linotype Company.

Type Design on the Computer, p.16
Sumner Stone at the computer in the Stone Type Foundry Inc. Photograph by Brian Wu.

Working with Stone

The text for some of the graphic examples is from existing works. The sources follow, along with notes about adaptations of the original text, typography, or design, where applicable.

Travel Guide, p.23
Adapted from:
Michelin Green Guide French Riviera-Côte d'Azur
First edition, pages 101-103
Pneu Michelin, Services de Tourisme
The map is a simplified version of the map appearing in the guide. The table of temperatures does not appear in the guide; it was fabricated for this example. The general design and typographic choices were copied, with Stone substituted for the original typeface.

Dictionary, p.24
©1985 by Houghton Mifflin Company
Adapted and reprinted with permission from *The American Heritage Dictionary*, Second College Edition
Text is verbatim; typography adapted from original.

Programming Manual, p.25
Glenn C. Reid, Adobe Systems Inc.
PostScript: Language Program Design
Palo Alto: Addison-Wesley, 1988
Text is verbatim, but taken from discontinuous passages. Typographic style adapted from original. Reprinted with permission of Adobe Systems, Inc.

Body & Soul, p.29
Carolyn Coman and Judy Dater
Body & Soul: Ten American Women
Boston: Hill & Company, 1988
This is an exact reproduction of the cover design. Design and typesetting by Lance Hidy. Photograph © 1988 by Judy Dater.

Ten Philosophers, p.30
Albert Hofstadter and Richard Kuhns, editors
Philosophies of Art and Beauty
New York: Modern Library (Random House), 1964
Selection from Martin Heidegger, *Der Ursprung des Kunstwerkes* (originally published 1950)
Title page is fictional, but text of chapter-opening page is taken verbatim from this anthology.

Photography Book, p.31
Photograph by Diane Cassidy, Cupertino, California. Text by Matthew Gaynor.

China Book, pp.32–33
Reset from:
Immanuel C. Y. Hsü
The Rise of Modern China
Fourth edition
©1970, 1975, 1983, 1990 by Oxford University Press, Inc. Used by permission.

Shakespeare, p.34
William Shakespeare: The Complete Works
Alfred Harbage, general editor
New York: Viking Press, 1977
Verbatim excerpt from *As You Like It*.

Newsletter, p.37
Text by Anne-Marie Fink. Photographs by Brian Wu. Specimen of *Hypolimnas dexithea* from the collection of Brian Wu.

Newspaper, pp.38–39
"The Media is the Mess" and "After Lin: 'Who and What'"
The Yale Daily News
Text is verbatim, except for name changes and the creation of cross headings and pull quote. Text for "Perhaps a New Aesthetic..." by Anne-Marie Fink. Photographs by Brian Wu.

Computer Display, p.43
Tiger image is taken from the "Slide Show" stack provided on disk with Apple Computer's HyperCard program. HyperCard is a registered trademark of Apple Computer, Inc., licensed to Claris Corporation. © 1987 Apple Computer, Inc. Used with permission.

Summer Program, p.54
Text used with the permission of the Director of Academic Affairs of the Yale University School of Art.

Sand Hill Road, p.56
Adapted from an ad designed by Brian Wu and used as an example in an Adobe promotional piece published in 1987. Illustrator is unknown.

Japan, p.59
Illustration by Pat Coleman, Menlo Park, California.

Looking at Stone

Caslon Specimen, p.71
Caslon Foundry type specimen, 1738. Courtesy of Wesley Tanner.

Specimens Text, pp.76–101
Lloyd Reynolds
Straight Impressions
Woolwich, Maine: TBW Books, 1979
Passages are taken from pp.28, 32, 35. Reprinted by permission of Thea Wheelwright and Rick Cusick.

Specimens Text, pp.102–103
Naissance de l'Écriture
Paris: Éditions de la Réunion des musées nationaux, 1982
Passage is from p.30.

Min Wang contributed the following designs:

Logos: CED, Art Forum, M&N, Han Feng, B (bird)
Yale Summer Program in Graphic Design brochure
What Is Grand Strategy? poster
A History of Typography poster
Japan poster (except text typography)
All items in "Typography as Art"